T0026131

i lemuri 12

This book is published in conjunction with

Texts
MUS.E - Valentina Zucchi

Project coordination
MUS.E - Roberta Masucci with Laura Chimenti

Editorial supervisione
MUS.E - Benedetta Pilla

Art direction
Paola Gallerani

Design
Elisabetta Mancini

Translation
NTL, Florence

Editing
Sandra Creaser

Colour separation
Premani srl, Pantigliate (Milano)

Printed by
Tipolitografia Pagani, Passirano (Brescia)

No part of this book may be reproduced or transmitted in any form or by any electronic, mechanical or other means without permission in writing from the copyright holders and the publisher.

ISBN: 978-88-3367-138-3
© Officina Libraria, Rome, 2021
Printed in Italy

To keep up to date on catalogue titles, news, events, press reviews and additional content, visit:

officinalibraria.net
Officina.Libraria
officinalibraria

Cover
Michelozzo's courtyard

Acknowledgements
Thanks to Andrea Bianchi, Maria Emma Cancarini, Gaia Chimenti, Rosemary De Meo, Stefano Giaconi, Laura Monticini, Edoardo Noferi, Lucia Segnini

Special thanks to Marco Jellinek

Photographic references
© Città Metropolitana di Firenze, Palazzo Medici Riccardi

© Antonio Quattrone

© Simone Lampredi

© Massimo Borchi/Atlantide Phototravel: cover image

© Per concessione del Ministero per i Beni e le Attività Culturali / Gallerie degli Uffizi, Florence, p. 12

© Per concessione del Ministero per i Beni e le Attività Culturali / Archivi Alinari, Florence: Tatge, George for Alinari, p. 5; Pedicini, Luciano for Alinari, p. 53

Valentina Zucchi

PALAZZO MEDICI RICCARDI

ENGLISH GUIDE

OFFICINA
LIBRARIA

TABLE OF CONTENTS

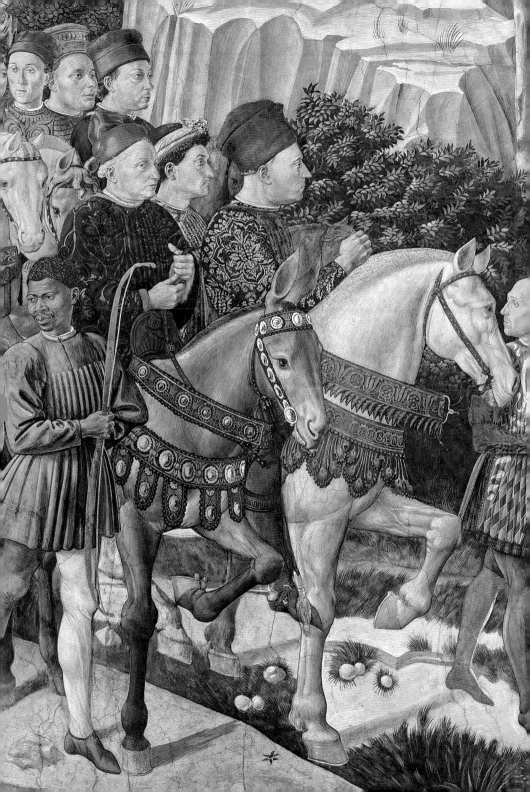

INTRODUCTION

A visit to the Palazzo Medici Riccardi is a unique experience. To be right in the heart of the city centre, in the place that was, and is, the symbol of the Medici family and of the whole Renaissance, where great historic figures like Cosimo the Elder, Piero the Gouty and Lorenzo the Magnificent once lived, and which witnessed the presence and endeavours of the greatest artists of the Florentine Quattrocento, immediately conveys a rather special sensation.

However, this palace is something more than that: not just an icon of times past, but an emblem of Florentine history stretching down from the Renaissance to the present day. Indeed, its architecture offers a chance to read a complex layering richly infused with the atmosphere conferred by time.

The palace is like a living organism, with a variety of features, vicissitudes and functions to be read and discovered. Still occupying the building today – since 1874–75 – are the offices of the provincial administration (now Metropolitan City of Florence) and the city's prefecture; it hosts temporary exhibitions, conferences, lectures and cultural events; the public can access the Biblioteca Riccardiana and the Biblioteca Moreniana, which house valuable manuscripts and books passionately collected by the Riccardi family (who lived here from 1659 until the early nineteenth century), and by the canon Domenico Moreni. Some of the palace's rooms are still used today by the Istituto Storico Toscano della Resistenza e dell'Età contemporanea, which was originally based in the building.

However, the visitor route around the building focuses principally on the periods when it was the home of the two families: the Medici, responsible for the initial layout and construction of the palazzo – an exemplary and magnificent prototype of a Renaissance aristocratic dwelling – and the Riccardi family, who made significant additions and modifications that are still evident today.

THE RISE OF THE MEDICI AND THE MEDICI QUARTER

The palazzo's history began in the spring of 1445 when work began to clear the area and subsequently erect the building. The project was commissioned by Cosimo the Elder (1389–1464) and the architect was Michelozzo di Bartolomeo (1396–1472). The aim was to build a new residence for the Medici family – in rapid ascendency – as part of a specific urban planning strategy in Florence.

As early as 1169 the Medici had had a tower built for themselves right in the centre of Florence, near the Mercato Vecchio in the parish of San Tommaso (close to the street that is still called via de' Medici today). But family members are first named in records at the beginning of the thirteenth century: Bonagiunta is mentioned as one of the councillors of the *comune,* while his brother Chiarissimo, head of another important branch of the family, lent money to the monastery of Camaldoli; later, in the 1260s, Averardo made the first pur-

chases of land and farms in the Mugello. These initial references already indicate that the Medici were beginning to establish themselves in finance and banking, prevalently based on usury. Both shrewd and lucky, they accumulated a growing political and economic fortune, rising to become one of the most powerful Florentine families at the beginning of the fourteenth century. Out in the Mugello countryside, they extended and consolidated their presence over the course of the century, but invested heavily in property in the city as well, where they took an interest in a new area in north Florence, called Cafaggio. The name, which means 'wood', was a quieter urban area but still very close to the Cathedral and strategic from a commercial point of view: the statutes of 1322–1325 made provision to open up via Larga (now via Cavour), a wide, quiet road running north to the grain and fodder market of Orsanmichele. Here, on the corner with via degli Spadai e degli Ispronai (now via Martelli), the Medici bought their first houses, followed in 1349 by the nine parts of a "palazzo with a courtyard, vegetable garden and well" (a little north of the present-day one). The purchase was completed by 1375, the year in which the family are recorded as the owners of six adjoining houses on via Larga, within the gonfalone of the Leon d'Oro, one of the sixteen administrative districts into which the city was divided. The desire nurtured by Cosimo – the son of Giovanni di Averardo known as Bicci, the true founder of the Medici's success – to build a palazzo in the area was therefore in keeping with the family's acquisitions and formed an important piece in the puzzle of a broader design to create an entire Medici quarter, together with the basilica of San Lorenzo, the convent of San Marco and, some time later, the Medici gardens, the famous *orti* of Lorenzo the Magnificent.

Cosimo, later known as Cosimo the Elder, inherited considerable financial assets from his father (in the 1427 declaration to the *catasto* he was, with 81,072 florins, the second richest person in the city after Palla di Noferi Strozzi), but also an acute business flair and a political line at once prudent and authoritative. Together with his brother Lorenzo, he found himself at the head of the flourishing Medici Bank – now well established not only in the city but further afield in Italy and Europe – and the owner of numerous properties. Overtime, Cosimo further consolidated and increased the family's assets and political standing, skilfully steering a path between rivalries and factions. He exercised a pre-eminent role in the city for over three decades and became one of the most powerful businessmen in Italy: "with manifest virtues, and secret and hidden defects, he is little less than prince of a republic, which, though he is free, he serves" (Benedetto Varchi, *Storia fiorentina*, 1547–1565).

It was Cosimo who wanted a new house for the Medici, adjacent to the existing buildings (partly combined in those same years into a single "palagio", which acquired the name Casa Vecchia, and which would be entrusted to his nephew Pierfrancesco in 1451, in order to be embellished over the following decades with celebrated artworks such as Sandro Botticelli's *Primavera* and

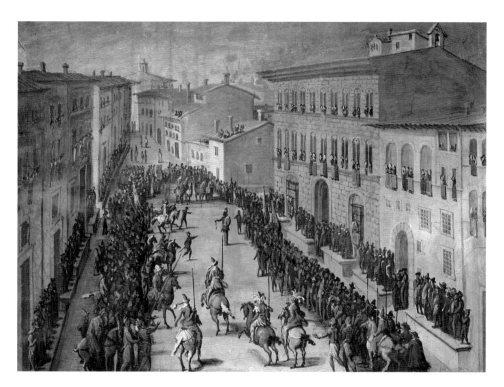

Giovanni Stradano, *Saracen Joust*, 1561. Florence, Museo di Palazzo Vecchio.

Minerva and the Centaur, and Michelangelo's *Saint John the Baptist*), and befitting the status the family now enjoyed – a Renaissance and typically Florentine noble residence. The new palazzo would serve both residential and commercial functions, but above all, it would be the perfect symbol of what was by now the family's undisputed political and economic importance, at the heart of a Medici area in a phase of expansion: Cosimo continued and increased the commitment made by his father Giovanni to the surrounding area, not only supporting work on the church of San Lorenzo, but also the church and convent of San Marco, home to the Dominican Observants, and the nearby confraternities of the Fanciulli, Tessitori and Magi.

As regards the palazzo, legend has it – thanks in part to the pen of Giorgio Vasari – that the design was initially entrusted to Filippo Brunelleschi: he reportedly came up with a model for Piazza San Lorenzo, with the entrance opposite the church, but it was deemed too ambitious or costly by Cosimo. This suggestion cannot be verified, just as it is debatable what design role Brunelleschi played in the realization of the existing building. What is undisputed is its spatially and symbolically strategic position in the city: Palazzo Medici Riccardi is still visible from Piazza Duomo, and this was even more marked at the time of Cosimo, when the road that is now

via Martelli was narrower and curved; conversely, the view from the windows of the Medici house offered – they still do – a view both of the Cathedral and of Palazzo della Signoria, the two centres of city power.

> Michelozzo was so intimate with Cosimo de' Medici that the latter, recognizing his genius, caused him to make the model for the house and palace at the corner of the Via Larga, beside S. Giovannino; for he thought that the one made by Filippo di Ser Brunellesco, as it has been said, was too sumptuous and magnificent, and more likely to stir up envy among his fellow-citizens than to confer grandeur or adornment on the city, or bring comfort to himself. (Giorgio Vasari, *Le vite de' più eccellenti pittori scrittori e architettori*, 1568).

The palazzo thus became the residence of the Medici family and a tangible sign of their role, embodied first by Cosimo the Elder, then by his son Piero (1416–1469), known as Piero the Gouty due to health condition, and then by Lorenzo the Magnificent (1449–1492).

THE PALAZZO BETWEEN THE SIXTEENTH AND SEVENTEENTH CENTURY

At the turn of the century, the palazzo reflected the alternating fortunes of the Medici: in 1494, Lorenzo's son Piero the Fatuous (1472–1503) fled from Florence, the Medici were exiled and a large part of their assets were confiscated, stolen or seized. They returned in September 1512, with Lorenzo the Magnificent's sons Giovanni (1475–1521) and Giuliano (1479–1516), and

grandson Lorenzo (1492–1519): a few months later Giovanni was elected pope with the name of Leo X. Their first aim was to re-establish the Medici's primacy in the city, but also to recover their family assets.

In those years the palazzo was occupied by Lorenzo, who became captain general of the Florentine Republic in 1515, together with his mother Alfonsina Orsini; and in September 1518, Lorenzo celebrated his wedding to Madeleine de la Tour d'Auvergne in the palace gardens. The event was the occasion for a major renewal of the area, which was surfaced with flat paving stones. The following year Madeleine gave birth, in the Palazzo Medici, to Caterina, who later became the queen of France. After Lorenzo's death, the family's political legacy was shouldered by Giulio, the cardinal archbishop of Florence and cousin of Leo X, and Cardinal Silvio Passerini, who was delegated with the task of overseeing political and administrative affairs in Florence after Giulio himself became pope with the name of Clement VII in 1523. Passerini installed himself in the palazzo together with the young Ippolito (1511–1535) and Alessandro de' Medici (1511–1537).

In 1527, however, following the Sack of Rome, there was a fresh revolt against the Medici, forcing them to leave the city. They returned definitively three years later, after an exhausting siege by imperial and Medici troops: Alessandro de' Medici was named as the first duke of Florence and lived in the palazzo. Pope Clement VII's commissioner, Baccio Valori, also moved in, before being replaced the following year by Niko-

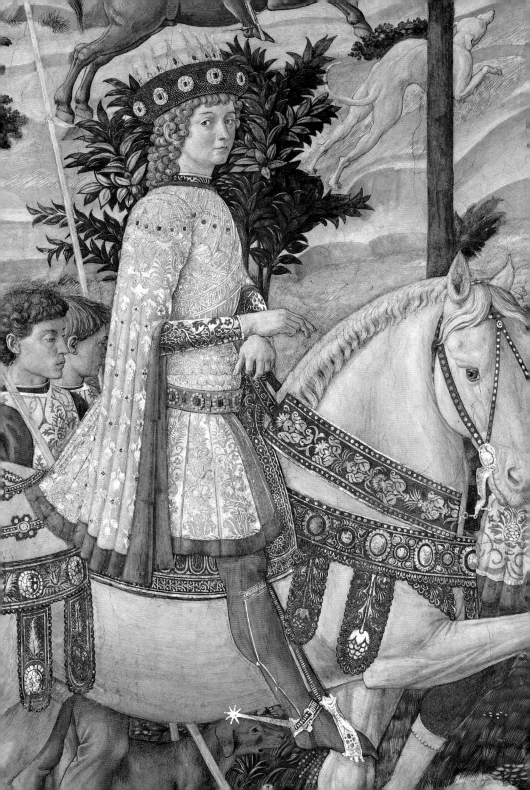

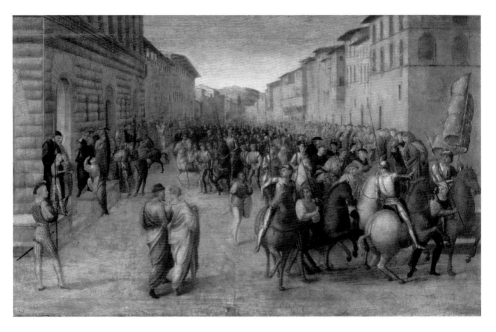

Francesco Granacci, *The Entry of Charles VIII into Florence*, 1517. Florence, Gallerie degli Uffizi.

laus von Schömberg, the archbishop of Capua, succeeded, a year later, by Cardinal Innocenzo Cybo. Alessandro was responsible for the lunettes of the old open loggia, already blocked up, painted by Giorgio Vasari with four scenes from the life of Caesar to mark the visit of Emperor Charles V in 1536. Charles stayed in the ground-floor apartment, decorated with the utmost splendour for the occasion. In the same year Alessandro married Charles's daughter, Margaret of Austria, and the palazzo was the setting for the celebration of "a beautiful banquet to which all the most noble women and all the leading lords and gentlemen of the city were invited, and after eating, there was much dancing, and afterwards a comedy was performed" (Benedetto Varchi, *Storia fiorentina*, 1547–1565). The future did not live up to expecta-

tions: in January 1537 Alessandro was murdered treacherously by his cousin Lorenzo in the old Medici house next to the palace. His successor was Cosimo de' Medici (1519–1574), the son of Giovanni delle Bande Nere, who resided in via Larga and, two years later, celebrated his nuptials with Eleonora di Toledo. The building was lavishly adorned and there was a splendid wedding party; the garden, or second courtyard, was closed in at the top by an awning and surrounded with celebratory paintings, making it look just like a real room: here Antonio Landi's theatrical comedy, *Il Commodo,* was performed, complete with musical interludes and marvellous stage scenery.

However, on 15 May 1540 Cosimo I moved his residence to the seat of government, the Palazzo Vecchio. The Palazzo Medici was kept for officials

Giuseppe Zocchi, *View of Palazzo Medici Riccardi*, 1744. Florence, Palazzo Medici Riccardi.

and court needs; in 1553 it was given over to the duchess Eleonora's brother, Don Luigi, and his family; a few years later, Cosimo's daughter Isabella (1542–1576) went to live there with her husband Paolo Giordano Orsini. In 1572, a fire compromised part of the building.

Don Antonio de' Medici (1576–1621) is also recorded as having lived in the palazzo with his three children; in the early seventeenth century, Cosimo I's grandson Don Pietro (1592–1654) also stayed in the palace, while in the second courtyard a workshop was established for stonemasons working on the nearby Chapel of the Princes.

In 1609 the building was inherited by Carlo de' Medici (1596–1666), Ferdinando I's third child and a young boy at the time. He left it for good in 1621, when he was already a cardinal, in ex-change for the Casino di San Marco, taking with him the main moveable goods remaining there. Relatives, grand-ducal officials, illustrious guests and court artists continued to sojourn there, including Matteo Nigetti, the grand-ducal architect and the director of works of the Chapel of the Princes, and Evangelista Torricelli, the successor to Galileo.

FROM THE RICCARDI
ACQUISITION TO THE PRESENT
DAY
The first information regarding the family dates to 1350 and concerns Anichino di Riccardo, a tailor who arrived from Germany and married a wealthy Florentine widow, to whose dowry the start of the family's economic fortunes is attributed. It was their son Iacopo who established a successful trading com-

pany and made significant purchases of landed property. When the first catasto (tax declaration) was held in Florence in 1427, the Riccardi family was already one of the richest in the city, and probably already had dealings with the Medici family. The sixteenth century saw the consolidation of the family's desire for social standing and its commercial and entrepreneurial endeavours, with the founding of the Riccardi Bank, operating first in the city and then in Italy and Europe. The family also continued to purchase property both in Pisan and Florentine territory: the villa of Castel Pulci (1590) near Florence and, in the city itself, first the palazzo of Bianca Cappello in via Maggio (1586), and soon afterwards the palazzo with a large garden in via Gualfonda (1598), which became the ideal backdrop for a growing and prestigious collection of sculptures, busts and ancient reliefs, accompanied by an equally substantial collection of books, manuscripts, medals, coins, cameos and works of art – icons of the family's ascent. Alongside the love for antiquities, art, literature and the sciences (a botanical garden was laid out in the Palazzo Gualfonda), at the end of the sixteenth century the family embarked on a political career: besides ties with the grand-ducal court and various posts and responsibilities received from the Medici (for instance, Riccardo Riccardi's successful mission to Danzig and Lübeck to buy grain and provisions during a serious famine), there were important aristocratic marriages, with a series of appointments and attestations of social recognition, culminating in the conferral of the title of marchese in 1606.

The ascendency continued with the nephews of Riccardo Riccardi (1558–1611), Cosimo (1601–1649) and Gabriello (1606–1675), who increased the family's political activities in the service of the Medici grand-dukes, receiving the marquisate of Chianni near Pisa in 1629. Gravitating increasingly around the Medici court, and fond of luxury and lavish spending, during the seventeenth century the Riccardi family gradually lost interest in and the capacity to directly manage their commercial and industrial activities and investments. While Cosimo pursued a military career, first as a general and then as governor of Livorno, Gabriello became a diplomat: first, he served as Tuscany's ambassador to the Spanish and papal courts, rising to become, in 1656, first majordomo, the highest post in the grand duke's court, and an authoritative presence on the State Council of Florence until his death.

It was by virtue of his intense political and diplomatic work, and the significant loans he made to the grand duke's coffers, that Gabriello Riccardi signed a contract with Ferdinando II Medici on 28 March 1659 to purchase the palazzo for 40,000 scudi. An important and onerous decision, the culmination of a precise strategy of social ascent, it was followed immediately by a major extension and renovation project. The driving forces behind this were, besides Gabriello, his nephew Francesco (1648–1719), who was also first majordomo from 1693; he commissioned the most significant and sumptuous works, including the extension of the building along via Larga and the magnificent Baroque-style interior decorations.

The large-scale modifications made by the Riccardi family can essentially be related to three different phases, coinciding with the architects who oversaw the works: Ferdinando Tacca (1659–1669), Pier Maria Baldi (1670–1685/6) and Giovan Battista Foggini (1686–1695 and 1718–1719).

For the renovation work, the Riccardi family ultimately spent three times as much as they did for the initial purchase: the account books in 1718 recorded a total sum of 116,627 scudi.

Francesco Riccardi, educated by the highly erudite tutor Alessandro Segni (in whose company he went on a Grand Tour to major European cities) and a contemporary and friend of Cosimo III de' Medici, also pursued a career in politics and public life which included missions to Rome and Vienna. He became the grand duke's first majordomo in 1693, and in 1669 he married the wealthy Cassandra Capponi; although the marriage brought with it a large legacy, added to which there was an upturn in the family's business and investments, the end of the century was marked by an increasingly lavish and luxurious lifestyle, with parties, dances and receptions on a princely scale. Though the Riccardis remained one of the city's richest families, the gradual increase in spending was accompanied by a marked decrease in trading activities and a constant dip in income: Francesco's son Cosimo (1671–1751) ran up the first debts and was constrained to introduce measures to restore the family finances. His three children had to do the same, until, in the mid-eighteenth century, the family's assets were definitively divided up.

The palace remained in the family's hands for the whole of the eighteenth century, becoming one of Florentine high society's favourite places, with its sumptuous parties, and an absolute must for travellers of high social standing, until it became state property in 1810. Four years later the building was sold to the grand-ducal government for 49,600 scudi. This entailed a process of adapting the palazzo to its new functions and the new offices, including the Catasto, the Accademia della Crusca, the Accademia dei Georgofili, the Ufficio del Corpo degli Ingegneri, but also the Cassa di Sconto, the Cassa Centrale di Risparmio and even the Guardia Nazionale.

In the period when Florence was the capital of Italy (1865–1871), the palace housed the ministry of the interior, police headquarters and the telegraph office, prompting further major alterations inside the building.

In 1874, after the capital had been moved to Rome, the palazzo became the seat of the Province of Florence, and the following year of the prefecture. Together with the arrival, from 1875 onwards, of works in temporary deposit belonging to the Florentine Galleries (paintings, tapestries and sculptures, but also furnishings and ornaments), major adaptations were carried out, culminating in the establishment in 1911 of a special "Commission for the Reorganization of the Palazzo Mediceo Riccardi"; headed by Arturo Linaker and Enrico Lusini, its aim was to ascertain what work needed to be done to restore, as far as possible, the appearance of the building to what it had been at the time of the Medici and Riccardi families.

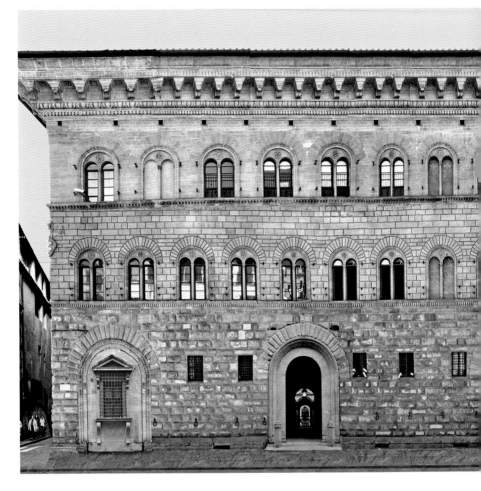

1 THE FAÇADE AND EXTERNAL ELEVATIONS

The façade that looks onto what is now via Cavour is the result of a sophisticated stylistic fusion between the two great periods of the palazzo's history, first when it was the residence of the Medici and then that of the Riccardi family: the first ten biforate windows in the southernmost part of the building correspond to the section designed by Michelozzo, while the other seven – significantly distinguished by the heraldic key of the Riccardi family – were added in the seventeenth century. They, together with their architects, builders and stonemasons, were responsible for significantly extending the façade of the building; rather than grafting on a new and modern section, they maintained the original style in keeping with the past.

But if we try to imagine the proportions and dimensions of the original Medici dwelling, a Renaissance master-

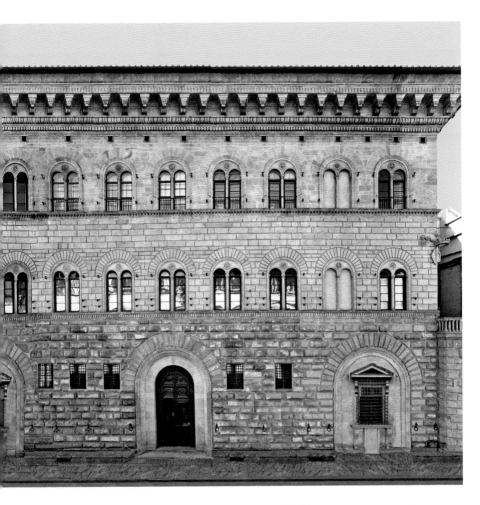

piece that succeeded in paying tribute to antiquity while at the same time expressing a wholly modern and majestic taste, we can grasp the undoubted originality of the work in comparison to the city's noble palazzos, making it a benchmark for the next fifty years.

In the fifteenth century, the palazzo had almost a square plan, conceived according to rigorous geometric canons and a specific numerical symbolism. The aim was to give concrete shape to an ideal harmonic measure, the cornerstone of Renaissance architecture: the main façade was on via Larga, punctuated by ten biforate windows on three floors, with a secondary façade on via dei Gori, with nine biforate windows; an embattled wall, with incised decoration and rustication on the corners, bordered the garden facing towards via dei Ginori. Antonio Averlino known as Filarete, for whom the building was the embodiment of the ideal palazzo in the

humanist age, as outlined by Alberti, described it as follows:

> Its shape is square, which on one side, namely from the corner of San Lorenzo to the corner of Via Larga, [is] [93.5] *braccia*; and from the corner of Via Larga until the end is [70] *braccia* and from the opposite corner, namely from the part towards San Lorenzo to the end of that side, is [70] *braccia*. Its height from ground to roof is [42] *braccia*. (Antonio Averlino detto Filarete, *Trattato di Architettura*, 1465).

At the time of the Medici, like today, the main entrance was at via Cavour 1, but there was a service entrance on the north side and openings in the corner loggia, consisting of two broad arches, one on via Cavour and the other on via dei Gori. The loggia, comprising a square-plan cross-vaulted space, was included in the original design as a strategic diaphragm between the residence and the city. Conceived "for the convenience and assemblage of the citizens" (Giorgio Vasari, *Life of Giovanni da Udine*, 1568) and equipped with a useful *panca da via* (stone street bench), it was a vital place for the family's financial and political dealings. It was closed at the wishes of Pope Leo X between 1516 and 1517, with the blocking up of the arches and the insertion of the very first *inginocchiate* ('kneeling') windows – attributed to the genius of Michelangelo Buonarroti – so called because they were very wide windows with a windowsill supported by curvilinear brackets reminiscent of two legs in a kneeling position.

The building is faced entirely with bare *pietra forte,* a typical local sandstone from quarries near the city, carved into large, rusticated blocks for the ground floor and becoming gradually less pronounced on the upper floors. The lower register, in fact, has strongly protruding blocks, punctuated by large arched apertures with carved keystones, bronze rings for horses, lamps and flags. A denticular string course marks the start of the *piano nobile,* characterized by less massive and more carefully shaped ashlar masonry; standing out against it on the corner is the Medici shield, also repeated towards the garden. Further up, the stone on the second floor is smooth, with a brownish tone that sets it apart from the floors below. Finally, at the top, a band of ovule moulding precedes the imposing cornice, punctuated by stone brackets. All the biforate windows are decorated in the central section, multiplying to a previously unseen degree the heraldic insignia of the Medici family: alternating with the Medici arms is the diamond ring with three feathers and a flower with five petals.

The side elevation, along via de'Gori, has an embattled wall delimiting the garden, with blocks made to resemble the real rustication on the façade; the same was probably done on the north elevation before the changes made by the Riccardi family.

Important events, including jousting contests and spectacles, took place in front of the palace in the fifteenth and sixteenth centuries, extending out into public space that aura of magnificence to which the family aspired, and which was so well articulated inside the building. One such memorable episode, for example, was the night-time *pas d'armes*

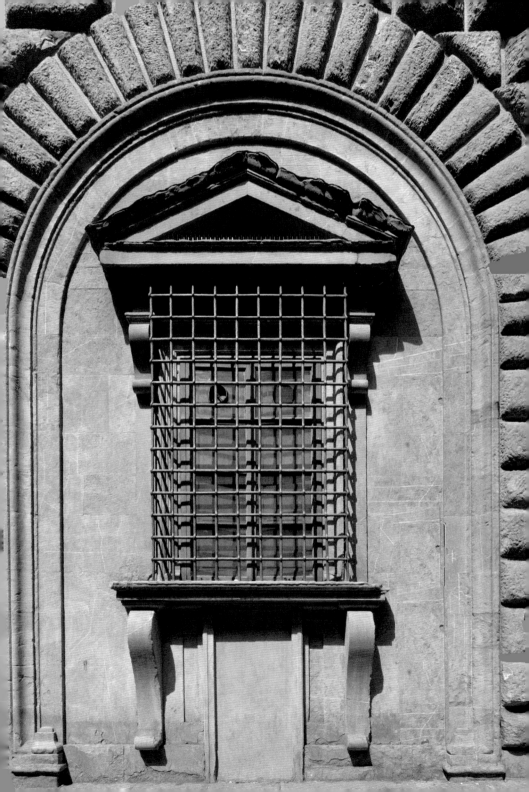

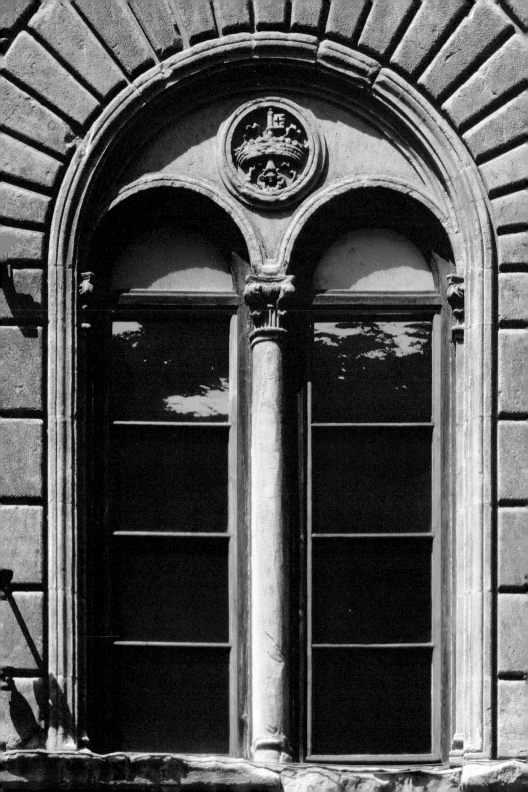

held in honour of Galeazzo Maria Sforza, a guest at the palace on the occasion of Pope Pius II's visit to Florence in 1459. The event was led by an extremely youthful Lorenzo and followed by a cart with the Triumph of Love. For the occasion, as would also happen in the decades that followed for the most important celebrations, the façade was entirely clad with tapestries and brocades: "nothing could be seen of the wall, all coverings of great value, only a great number of fabrics decorated with every kind of figure, so lifelike that they seemed real" (*Terze rime in lode di Cosimo de' Medici e de' figli...*, Florence, Biblioteca Nazionale Centrale, ms. Magl. VII, 121).

The balanced Medicean architecture was rendered markedly unbalanced by the Riccardi modifications. The first steps towards extending the edifice were made at the end of the 1660s when the Riccardi family bought a house on via Ginori; the extension on via Larga would take longer, as the house was occupied by the Marchesa Alessandra Baldini del Bufalo. The Riccardi launched a court case, which they only managed to win in 1678. Dating to the following year, in fact, was a letter attesting to the reaction of public opinion to the start of the work, which adhered strictly to Michelozzi's style: "a mountain of stones to be worked into blocks heaped up in front of the house of His Excellency Marchese Riccardi has excited the curiosity of everyone who passes. The Master Builder said to someone that the façade is to be clad as far as the house of the Ughi" (*Letter of Lorenzo Magalotti to Apollonio Bassetti dated 31 January 1679. Florence, Archivio di*

Stato, Mediceo del Principato, 1525). The work was suspended in 1682 but resumed five years later under the supervision of the stonemason Agnolo Tortoli and was completed in 1689, with a decidedly high final cost: 25,000 scudi. The choice made by the Riccardi family, quite unusually for the historic period, was to ensure absolute continuity with the Medici façade, thereby embracing its symbolic value and even using stone from the same quarries used by Michelozzo, so that the extension would not stand out.

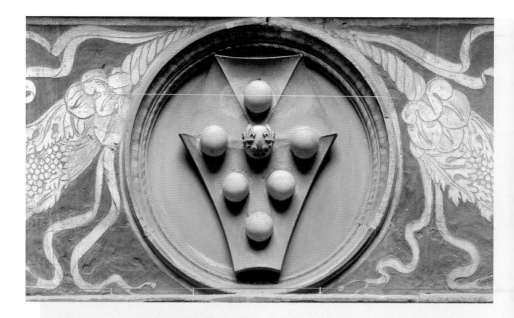

THE MEDICI COAT OF ARMS AND HERALDIC INSIGNIA

On the edge of the building, between via Larga and via de' Gori, is a stone coat of arms with the Medici heraldic insignia: seven balls or roundles arranged in a circle. It is not an isolated instance: in more or less explicit forms, the members of the Medici family made specific and widespread use of the family image on the building; the Medici insignia stand out at many different points inside and outside the building, adorning the architecture, works and decorations.

Various legends quickly sprang up regarding the red roundles – more familiarly known as balls – on a gold field. The story is told of an ancient knight named Averardo Medici, who defeated the terrible giant Mugello and whose golden shield carried the signs of the blows received from the foe's mace; an alternative story has Averardo, this time a physician, treating the emperor Charlemagne, who had been injured in the Florentine countryside, with special cupping-glasses or with medicinal pills; according to some, they recall the golden apples of the Garden of the Hesperides, jealously guarded by a dragon with a hundred eyes: for others, they evoke the golden coins, or bezants, so dear to the Medici, which already adorned the arms of the Arte del Cambio (moneychangers' guild) and which would be reused, with the colours inverted, for the family heraldic insignia. Of all these hypotheses, one stands out for its simplicity and historic plausibility: the balls were simply one of the most frequent figures in heraldry, echoing the bosses and iron fittings on battle shields. The colours, red roundles on a gold field, could also be viewed as congruent with the typical tinctures of the heraldry of the time. Initially, the number of balls on the shield, or field, was extremely variable, as was their ar-

rangement – at the Badia Fiesolana there is a shield with three roundles, while in others there are six, seven or even eleven – until, in the second half of the fifteenth century, six balls became stable, visual signs of the family's achieved grandeur. What is more, in 1465, Louis XI granted Piero the Gouty the distinction and honour of including the symbol of France in his insignia, a small shield with three gold fleur-de-lys on an azure ground. From then on, the red balls were accompanied by a blue one at the top with gold fleur-de-lys.

The family's armorial bearings are accompanied by a very widespread use of other Medici symbols in the palazzo. These would become increasingly personal in nature: unlike the heraldic shields, these insignia – perhaps echoes of the crests decorating helmets – have refined meanings and for this reason are often accompanied by a motto useful for deciphering the meaning. One notable one is the diamond ring, often together with the motto "SEMPER", which associates the value and hardness of the precious stone with the value of the Medici family members. The diamond ring is accompanied by three (sometimes two) feathers, which may reference the theological virtues and the Trinity and, if painted, are white, red and green. Piero's device was the falcon, while the perpetually renewing laurel branch refers to Lorenzo, who also displayed it on his standard in the famous joust in Piazza Santa Croce in 1469, together with the motto "LE TEMS REVIENT", 'the time comes again': a symbol with knightly connotations representing the new and golden age of the Medici, but also the ability to recover in the face of adversity.

Already a device by the sixteenth century was the ox yoke, accompanied by the motto "ENIM SUAVE", present on the base of the statue of Orpheus in the courtyard. This was the personal device of Pope Leo X: the reference in this case has an evangelical flavour, a reminder that every yoke is gentle with the support of the Lord (Mt, 11–30).

From then on, as would be attested by Paolo Giovio's *Dialogo delle imprese militari et amorose,* published in 1555, the illustrious figures of the house of Medici, and others as well, would choose individual devices to represent their qualities and characteristics. In the meantime, however, the centre of Medici power had shifted to the civic palace. A new chapter in the Medici's history was about to be written. ◻

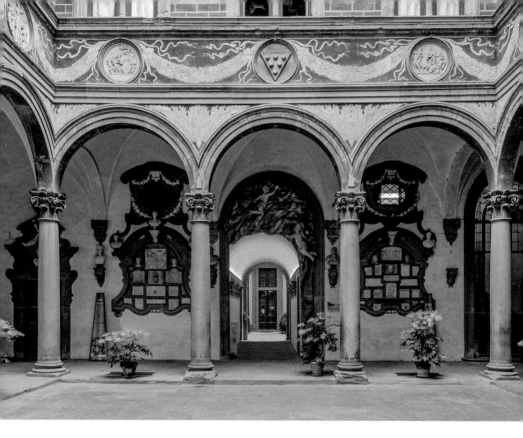

2 THE COURTYARD OF THE COLUMNS OR MICHELOZZO'S

Inside the main entrance is a barrel-vaulted vestibule leading to the courtyard. The heart of the Renaissance palazzo, the courtyard is one of the most sophisticated expressions of the fifteenth-century design, modulated with elegance and purity of style on the classical architecture of the open galleries on the ground and upper floors, albeit embellished over time by significant interventions. The sides, of varying breadth, each comprise five spans supported by corbels and columns in grey *pietra serena* sandstone with rounded arches. There is a high frieze punctuated by three tondos on each side, which are linked to each other by plant festoons

and ribbons executed with the *sgraffio* technique: prominently placed in the middle of each side is the Medici coat of arms, flanked by monumental replicas of eight antique cameos, publicly visible signs of the very private Medici collections. The medallions, produced around 1455, are the work of artists from Donatello's circle. They reproduce sophisticated classical carved gems, which were collected by the Medici – who had a great passion for antiquities – and are now in the archaeology museums of Naples and Florence: starting from the south side, to the left of the entrance, there are, alternating with the Medici arms: *Diomedes with the Palladium* (A),

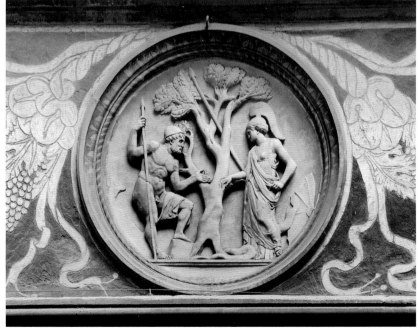

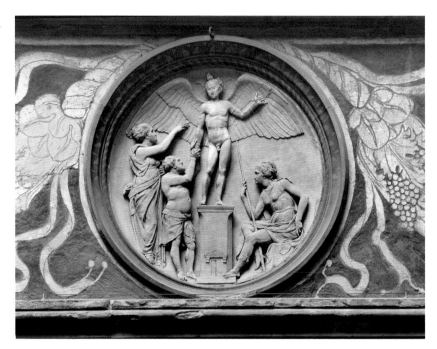

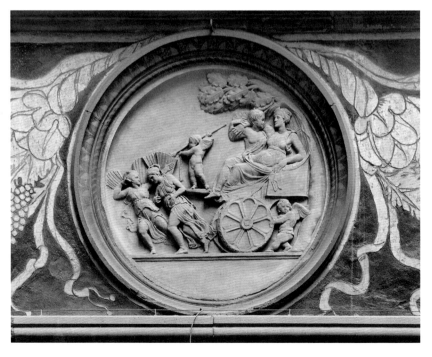

Satyr with the Young Dionysius, Athena and Poseidon (B), *Daedalus and Icarus* (C), *Eros Riding a Chariot, Dionysius and Ariadne* (D), *Centaur Shouldering a Basket, Scythian Prisoner.*

Like the pendentive and the frieze, the *piano nobile* also had *sgraffito* decoration, simulating a masonry facing broken by biforate windows and topped by a further and extremely elegant decorative band. The upper register, now glazed, was originally an open loggia, with columns supporting the upper trabeation.

The courtyard, like the loggia on the street, was conceived as a space for ceremonies, for gathering and for parties. It was also a waiting area, as Savonarola noted critically in relation to the long waits endured by citizens who requested an audience with Lorenzo the Magnificent: "an audience with the tyrant is very hard, and he keeps citizens waiting there for him for four hours, and the religious too; and he stays in his chambers with his friends and companions in his pleasures and pays no heed to those waiting for him" (Girolamo Savonarola, *Sermons on Amos and Zacharias*, 1496).

The stairs Lorenzo would have come down were not the current ones: they were in the south-east corner of the palazzo and consisted of rectilinear flights of stairs. In their place now is an elegant helicoidal staircase, which unfortunately is not accessible but is visible from the outside. It was built at the wishes of Gabriello Riccardi in the early 1660s, a wide spiral staircase (1660–1661) designed by the architect Ferdinando Tacca, who oversaw the first modernization work on the building.

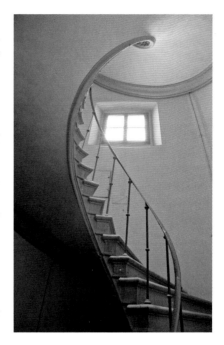

In the second half of the fifteenth century, it was around this courtyard and the adjacent garden, or second courtyard, that the main official and residential functions of the palazzo revolved, while the service activities were grouped around the two small courtyards on the north side, the courtyard of mules and the courtyard of the well:

The cellars are excavated to more than half their depth underground, namely, four *braccia* below, with three above for the sake of light; and there are also wine cellars and storerooms. On the ground-floor there are two courtyards with magnificent loggias, on which open reception rooms, chambers, antechambers, studies, closets, stove-rooms, kitchens, wells, and staircases both secret and public, all most convenient. On each floor there are apartments

with accommodation for a whole family, with all the conveniences that are proper not only to a private citizen, such as Cosimo then was, but even to the most splendid and most honourable of Kings; wherefore in our own times Kings, Emperors, Popes, and all the most illustrious Princes of Europe have been comfortably lodged there, to the infinite credit both of the magnificence of Cosimo and of the excellent ability of Michelozzo in architecture. (Giorgio Vasari, *Life of Michelozzo*, 1568).

A magnificent palazzo, then, and worthy of a king, as Pope Pius II (Piccolomini), who visited Florence in 1459, actually described it ("Cosmas [...] edificavit in urbe palatium rege dignum", he wrote in his *Commentari*, 1462–1463). Indeed, in the centuries to come, princes, grand-dukes and kings would be received and feted there. In front of the entrance, on an elegant plinth carved by

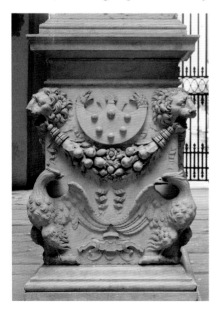

Benedetto da Rovezzano and Simone Mosca, stands a peaceable *Orpheus* sculpted by Baccio Bandinelli to a commission by Pope Leo X. It was placed in the centre of the courtyard in 1519, with Cardinal Giulio, the pope's cousin and the city governor, acting as a go-between. It later went to the Casino di San Marco when Cardinal Carlo de'Medici moved there and is recorded in the inventory drawn up at his death (1666). It returned to the palace in 1916, where it was reunited with its plinth (in a more rearward position), as part of a refurbishment. Baccio Bandinelli had originally proposed doing a depiction of David, in a sort of continuity with Donatello's *David,* which was here in the fifteenth century, but the pope chose the mythical Orpheus, who with the spell of his poetry, accompanied by the music of the lyre, had managed to tame savage men, ferocious animals and even inanimate things. An emblem of concord and gentleness, but also of the harmony of music, poetry and the universe, Orpheus stood as a perfect symbol of a new culture of peace, having even placated Cerberus, who is seen sitting docilely alongside him; and Leo X, the son of Lorenzo the Magnificent and a pupil of Marsilio Ficino, presented himself as a new Orpheus for Florence. The sculpture is a meditated reinterpretation of the *Apollo Belvedere,* an icon of classicism, and once featured a lyre as well; on the base are lion protomas supporting rich festoons and, above all, Medici devices: eagles holding *bronconi*, the family's coat of arms, the diamond ring with three feathers and the yoke, the personal device of Pope Leo X.

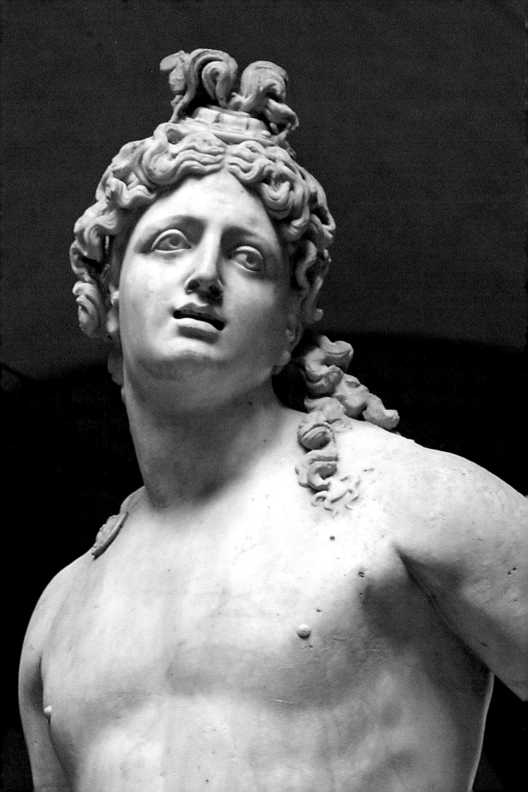

The return of the Medici to Florence in 1512 and the arrival of Leo X followed the tumultuous years of exile. Leo did not neglect to parade solemnly through Florence in 1515 on his way to Bologna, and to make provision for important works on the building: these included the closing up of the corner loggia and the commissioning of *Orpheus* from Bandinelli.

In its place, in the fifteenth century, we would have found nothing less than Donatello's *David,* the modern echo of an ancient model and an emblem of civic virtue and justice, underscored by the inscription: "Victor est quisquis patriam tuetur / Frangit iniusti Deus hostis iras / En puer grandem domuit tyrannum. /Vincite, cives!" ("The victor is whoever defends the fatherland / God crushes the wrath of an enormous foe / Behold! A boy overcame a great tyrant / Conquer, O citizens!") So, it is no accident that the work was confiscated by the Florentine Signoria in 1495, after the Medici were banished, together with *Judith and Holofernes,* which stood in the garden and was by the same artist. The bronze *David,* now in the Bargello, is rightly celebrated for the extraordinary naturalness of the limbs, of the pose and of the entire composition. It is a modern interpretation of classical measure: the young David, with the helmeted head of Goliath on the ground, is holding the sword and the stone, the weapons of the combat, in his hands, while on his head he has a broad hat and on his feet winged boots. As Vasari reminds us: "This statue is so natural in its vitality and delicacy that other artisans find it impossible to believe

that the work is not moulded around a living body" (Giorgio Vasari, *Life of Donatello,* 1568). Proud and reflective, it was already standing in the centre of the courtyard at the end of the 1450s, positioned on a tall, slender pedestal executed by Desiderio da Settignano, consisting of a base with "some fine harpies and some very delicate and well-studied bronze vines" surmounted by a column. The pedestal did not obstruct the view, so it was possible to catch a glimpse of the garden from the entrance: "he had made a simple column, on which he placed it, and the plinth below cracked and open, so that whoever went by outside saw from the street door the other door inside the courtyard opposite". It was around precisely this statue that high tables were prepared for Lorenzo the Magnificent's wedding with Clarice Orsini in June 1469, where water and wine were served to guests. The celebrations would then continue in the garden, with dancing and a banquet.

Like *Orpheus,* the tazza in red speckled marble with serpent-shaped handles positioned under the southern loggia is also from the sixteenth century. Attributed to Niccolò Tribolo, it is from the *Orto dei semplici* adjacent to the villa of Castello.

The walls represent one of the most ambitious projects undertaken by Francesco Riccardi to transform the courtyard into a kind of museum of antiquities, continuing the atmosphere already conjured up in his previous Gualfonda residence, where sculptures and marbles were displayed in the garden and adjacent gallery.

Here, besides the broken and over-

HOSPES.
AEDES CERNIS FAMA CELEBERRIMAS ATQVE
MAGNIFICAS A COSMO MEDICE PATRE PATRIAE, MICHELOZIO
ARCHITECTO ERECTAS A.S.P.MCD.CCCCXXX IN QVIBVS MAGNVS
ILLE SENEX SVCCESSORESQ.SVI IN R.P.FLORENTINA PRINCIPES ET
ALEXANDER DVX R.P.FLOR.PETRVS MEDICES COSMI I.TERTIVS
FIL.HABITARVNT, HIC A SENATV FLORENTINO, COSMVS MEDICES DVX
FLOR.PLENIS LIBERISQ.SVFFRAGIIS, CREATVS, AD QVINQVE ANNOS
SEDEM SVAM AC REGIAM HABVIT, CAPTIVOS MONTIS MVBLI
VICTORIAE TESTES VIDIT, NVPTIAS CELEBRAVIT REGIAM STIRPEM
FELICITER HODIE, REGNANTEM FVNDAVIT, VARIIS TEMPORIBVS
ROMANI PONTIFICES, ROMANI IMPERATORES, REGES, REGINAE
ALIIQ.PRINCIPES, INNVMERIQ, PROCERES, HOSPITIO EXCEPTI,
LEO X.TALIN ITV BONONIAM REDITVQ.CAROLVS.VIMP.QVI ORATORES
TVNETANI REGIS HIC SOLENNE TRIBVTVM SOLVERVNT, CAROLVS.VIII
GALLIARVM REX CARLOTA CYPRI REGINA.ET SARMATIAE REGINA
THOMAE REGIS FILIA, FRIDERICVS PRINCEPS SALERNI, FERRANDI
REGIS NEAPOLITANI F.E ET MARIA HIPPOLYTA, DVX CALABRIAE
GALEATVS MARIA SFORTIA MEDIOLANI DVX HIC LITERAE LATINAE
GRAECAEQ.RESTAVRATAE.MVTAE ARTES EXCVLTAE, PLATONICA
PHILOSOPHIA RESTITVTA, ACADEMIA FLORENTINA A COSMO I.
VERNACVLAE ETRVSCAE LINGVAE CVLTVI SACRATA, SEMPER HI
PARIETES COLVMNAEQ. ERVDITIS VOCIBVS, RESONVERVNT,
AEDES HASCE TANTAE GLORIAE VIX CAPACES GABRIEL CHIANNI
ET RIVALTI MARCHIO SENATORES FRANCISCI RICCARDI F.A. FERD. II
M.E.D.A. CIϽ.IϽ.C.LVIIII COMPARATAS IN POSTICA AVXIT PARTE
FRANCISCVS MARCHIO COSMI MARCHIONIS E.GABRIELIS SVPRADICTI
EX FRATRE NEP.ET HERES VETVSTAM AEDIVM MAGNIFICENTIAM
AEMVLAT V.S. ILLAS SACELLO, SACRIS RELIQVIIS REFERTO
VETERIBVS NVMMIS, ANAGLYPHIS, PICTVRIS, INSTRVCTAS,
BIBLIOTHECA, MVSEQ. SIGNIS, SCALPTIS CAELATISQ, GEMMIS,
INTVS FORISQ, DVPLO AMPLIAVIT A.CIϽ.IϽ.C.XC. VETEREM PARTEM
IN MELIOREM FORMAM REDEGIT ORNAVIT. ORNAT A.CIϽ.IϽ.CC.XV.

HOSPES.
MEDICEAS OLIM AEDES, IN QVIBVS NON SOLVM, TOT PRINCIPES
VIRI, SED ET SAPIENTIA IPSA HABITAVIT, AEDES OMNIS
ERVDITIONIS, QVAE HIC, REVIXIT, NVTRICES, NVNC ETIAM ERVDITO
LVXV INSIGNES ANTIQVITATIS ET ELEGANTIARVM THESAVRVM.

GRATVS VENERARE.

turned pediments above the entrances to the various spaces, and in addition to the austere Renaissance displays embellished with volutes and decorated with busts and vases, eight highly sophisticated cornices were put in place in the early eighteenth century. Made from *pietra serena* and stucco, and with a mixtilinear profile, they were designed by Giovan Battista Foggini and real-ized by the sculptor Giuseppe Broccetti (1718–1719). Embedded within these cornices in an orderly fashion were 98 antique fragments – epigraphs and reliefs – forming part of the Ricciardi family's substantial antiquarian collection, arranged according to purely aesthetic criteria. As early as 1687, Cosimo III had, exceptionally, granted permission for the collection of antiquities to be

taken from the Palazzo Gualfonda to the Palazzo Medici, overriding the ban on their movement expressed in his will by the family ancestor Riccardo Riccardi, who had begun the collection, but at the same time respecting his wish for their fame and notoriety to be enhanced: "because it pertains to decorum, and to the public glory of the city of Florence, that the said antiquities should be kept in the most conspicuous place of the city, more properly to be seen, and which serve both to furnish and to make the said palace of Via Larga more remarkable" (21 December 1687, *Motuproprio di Sua Altezza Reale Cosimo terzo, riguardante il Trasporto delle Statue, Medaglie ec. esistenti nel Palazzo del Giardino di Valfonda, al Palazzo di via Larga.* Florence, Archivio di Stato, Mannelli, 346 a, ins. 19).

As a result of the grand duke's concession, sculptures, busts and reliefs were distributed around the palazzo: in larger numbers in the ground-floor gallery looking onto the garden in the room of bas-reliefs on the *piano nobile* and in the courtyard. It was the courtyard of columns, then, that became home to around sixty antique or classicizing busts – still largely in place today – and some decades later, the eight imposing cornices, or "walled enclosures" already tried out in the Palazzo Gualfonda.

Dating to the same years was the insertion of the masks and faun faces in *pietra serena,* placed beneath the shelves for resting the busts, and the blocking up of the four windows looking onto the garden. They were replaced by niches with statues of saints and prophets produced by fourteenth- and fifteenth-century artists for the Cathedral façade, acquired by the Riccardi

family (the current ones are copies; the originals are in the Museo dell'Opera del Duomo).

All of this helped to adorn the courtyard and transform it into a kind of magniloquent atrium, as befitted the great noble palazzos of the age, and at the same time into a small antiquarian museum. This was in line with what had happened in the Medici era when busts of emperors and illustrious figures were placed above doors in deference to the "holy antiquity" that was so bedazzling in Rome, and to which the whole Renaissance looked, as we are reminded by Fra Giocondo in the dedicatory letter to Lorenzo the Magnificent.

Between the autumn of 1718 and the early months of 1719 Francesco Riccardi saw the realization of his decorative project, rendered explicit a few years earlier in the celebratory plaques on the walls: the one that stands out most is on

the south side, in white marble within a monumental frame in yellow marble, accompanied by two further inscriptions above the entrance arches on the eastern and western sides, all relating to the "precious relics of erudite antiquity" ("pretiosas antiquitatis eruditae reliquias").

The southern arm running along the loggia houses the rooms still called the Medici Museum, in memory of the project devised in 1929 to remember with original works, copies and reliquaries "the characters, the customs and the local memories of the Medici epoch", in line with what also happened elsewhere in the city. Today the rooms house temporary exhibitions. One of the rooms is the ancient Medici loggia on the corner of the palazzo, turned at the beginning of the sixteenth century into a closed space and further renovated after a fire in 1588, when it incorporated an adjacent studio. Traces of the original fifteenth-century architecture are still visible.

3 THE COURTYARD OF MULES

On the north side of the courtyard is a rich stucco decoration with theatrical hangings supported by putti, executed by Anton Francesco Andreozzi in 1688. The passageway leads to the courtyard now called the courtyard of the mules, a reminder of the small courtyard already in place here at least from 1531, alongside another small one called the well courtyard, added in the Riccardian period. Along this passage are twelve plaster and terracotta medallions painted to look like porphyry on green serpentine, with the profiles of illustrious Florentines from the past: on the left are Francesco Guicciardini, Dante Alighieri, Luigi Alamanni, Giovanni della Casa, Donato Acciaiuoli and Marcello Virgilio Adriani, and on the right Amerigo Vespucci, Vincenzo Borghini, Giovanni Boccaccio, Francesco Petrarca, Leon Battista Alberti and Pier Vettori. The medallions were inherited by Francesco Riccardi's wife, Cassandra Capponi, and were produced in the wake of the "grimacing faces" placed on the palazzo of Baccio Valori in borgo degli Albizi around a hundred years previously: a gallery of men deemed exemplary for their virtues and works, put there not only to honour

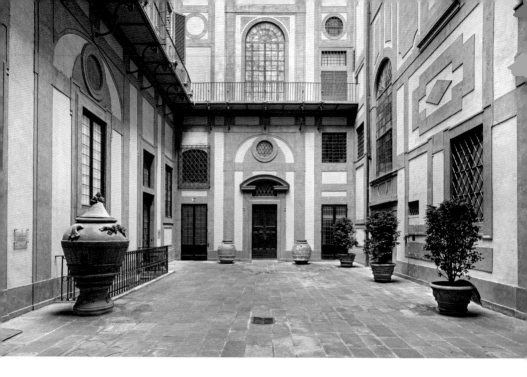

their memory but also to inspire others to similar endeavours. Further rooms give access to the courtyard of mules, and are now used for temporary exhibitions and the museum's education department; some are also used by the Istituto Storico Toscano della Resisten- za e dell'Età contemporanea, which was formerly based here and which studies anti-fascism and the Resistance, in part through activities for schools and the wider community. The courtyard gives access to the archaeology trail and the Museum of Marbles.

4 THE ARCHAEOLOGY TRAIL AND THE MUSEUM OF MARBLES

A ramp rebuilt in the Riccardian period leads to the basement, where visitors can trace the entire history of the site, from the Roman age through to modifications made in the nineteenth and twentieth centuries.

Archaeological excavations have uncovered important architectural finds (masonry, floors, wells, stairs, cisterns) and many artefacts. A selection of the finest ones is on display, divided according to function (heating – kitchen and food store – refectory – daily life) and arranged chronologically. The top ones in each cabinet are the most recent, while the oldest are at the bottom. There are braziers and stove tiles (but also nineteenth-century firebricks produced in Scotland), pots and pans, jars, jugs, plates, cups, glassware, oil lamps and

bronze utensils. These include surgical instruments and others used for cosmetic purposes; one currently unique find is a bronze *ligula* (small spoon) decorated in the form of a human figure, with a very detailed rendering of the anatomy.

It is known that there were already cellars in this area in the fifteenth century; originally there had also been stables, soon moved north of the courtyard. The inventory done when Lorenzo the Magnificent died in 1492 mentions the "time it used to be a ground-floor stable".

A little further on is a portion of the old riverbed of the Mugnone, an affluent of the River Arno deviated several times over the centuries to suit Florence's urban layout: this section corresponds to the primitive course of the river, about eight metres wide. Also on view are the remains of a Late Antique tomb (5th–7th century AD), close to which

there is a substantial block of masonry used as a foundation base for the Medici palazzo. The two wells and the floor of the old stables also date to Medici times. More recent items are the remains of ovens and the plumbing of three nineteenth-century radiators (1875).

The itinerary then moves on to the so-called Museum of Marbles, which contains a selection of classical works from the Riccardi family's antiquarian collections, started at the end of the sixteenth century. Knowledgeable and passionate collectors of antique marbles, they moved most of their pieces from the Gualfonda villa and distributed them around the building. After the acquisition of the palazzo by the State in 1814, only a part of the collection was moved; a large proportion is still housed around the building. Here in the museum, it is possible to admire, together with the

finds uncovered by the most recent excavations, a fine body of works. These are a group of marbles from the Roman age, copies of famous lost Greek originals, once identified as wise men, heroes or gods, or specific portraits. Among the cabinets displaying the archaeological finds in this area there is, for example, a portrait of Vibia Sabina, Hadrian's wife, complete with a sophisticated headdress, and one of a child dating to the third century AD, followed by the ancient head of Emperor Caracalla (on a modern bust), and an expressive, absorbed portrait of the Platonic philosopher Carneades, flanked by an extremely realistic portrait of an old man.

The large room that follows houses more portraits lined up along the right wall, the result of the combination of ancient portrait heads and modern busts: a young woman with plaited hair (possibly Otacilia Sevara, the wife of Philip

the Arab), followed by men, divinities and emperors. On the opposite side of the room are two busts of Euripides: the first is of the Farnese type, from the late Hadrianic or Antonine age, while the second is of the Rieti type, ascribable to the first century BC.

Also in the museum are the plaster casts of the busts of Augustus and Agrippa – the originals were given to Lorenzo the Magnificent by Pope Sixtus IV in 1471 and are now in the Uffizi – and those of Caligula and Nero, bought by the Riccardi family in 1669 and now also in the Uffizi.

The final section includes more male busts of intellectuals, philosophers and poets, identifiable as Thales of Miletus, Asclepius, Sophocles and Anacreon. Rounding off the collection are a bust of a young man with a headband, also interpreted as an Amazon, and a fine bust of an athlete, dressed in a chlamys and haldric.

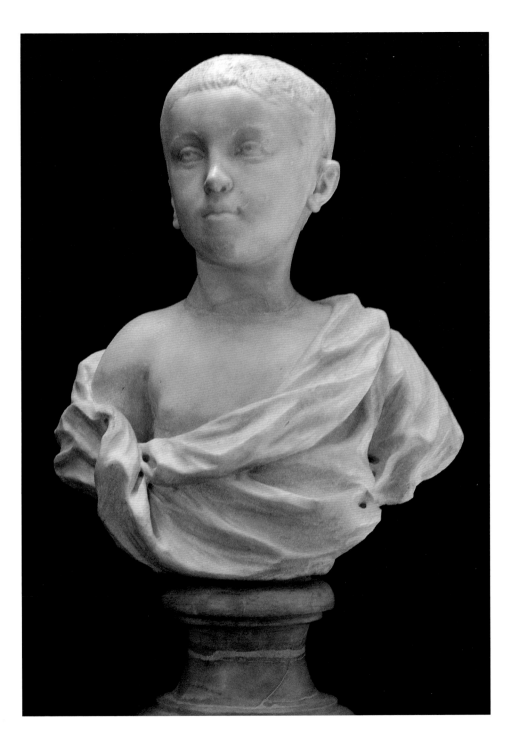

5 THE WALLED GARDEN

The garden, which once fully exemplified a peaceful and paradisaical *hortus conclusus* (an enclosed, secluded garden offering relief and inspiring reflection thanks to the delights of nature and art), was accessed in the fifteenth century via a small gate, above which there was an antique bust portrait of Emperor Hadrian (now in the Uffizi Gallery). Instead of the current niches, there were, as said, four small windows giving some light to the loggia.

What we see today is the result of work done at various stages over the centuries. In the Medici's time, there would have been a green space here with a three-arched loggia on the south side; above this was an upper terrace, probably another covered hanging garden, observed with amazement by the German Johan Reuchlin on a visit to Florence in 1482: "on top of the roof is a grove of trees, the garden of the Hesperides and the golden apples" (Johan Reuchlin, *De arte cabalistica*, 1517).

What the Medici garden looked like is not known, but it can be imagined as having regular-shaped lawns edged with box hedges imaginatively shaped by topiary art and capable of imitating any possible form: Alberto Avogadro, a guest of Cosimo de' Medici, remembered an elephant, a wild boar, a ship, a ram, a hare, a fox being chased by dogs, deer and many other animals; and when Galeazzo Maria Sforza visited in 1459, the Medici and Sforza arms were shaped out of the greenery: "a grass snake in the form of the emblem of Your Excellency, and alongside it is the shield with the coat of arms of the said Cosimo: this grass snake

and coat of arms are made from grass and planted in a piece of ground, so the more the grass grows, the more the emblems will grow" (Letter from Niccolo de' Carissimi to Francesco Sforza, 17 April 1459, Archivio di Stato di Mantova, Gonzaga, 1099, fasc. 77, c. 446r).

In the garden and portico, besides the natural elements, there was also a further display of antiquities: ancient busts were placed over the doors: a fountain was crowned with a bronze horse's head, identified as the one now in the city's archaeology museum; while on each side of the gate there were two statues of Marsyas, the satyr who dared to challenge Apollo to a musical contest and was flayed when he lost:

At that time, Cosimo de' Medici had received many antiquities from Rome, and he set up a very handsome statue in white marble of Marsyas, bound to a tree-trunk and ready to be flayed, inside his garden gate, or rather his courtyard [...]. As a result, his grandson Lorenzo, who had come into possession of a torso with the head of another figure of Marsyas sculpted in red marble, that was very ancient and much more beautiful than the other one, wanted to set them up together, but was unable to do so because the second figure was so damaged. Therefore, he gave it to Andrea to restore and refinish, and Andrea made the legs, thighs, and arms missing from this figure out of some pieces of red marble; it all came out so well that Lorenzo was very satisfied and had it placed opposite the other statue on the other side of the door. This ancient torso, made for the figure of a flayed Marsyas, was worked with

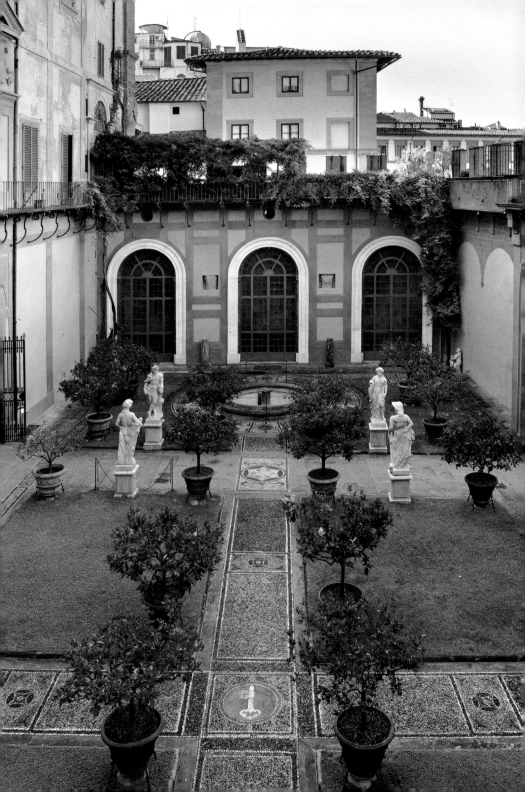

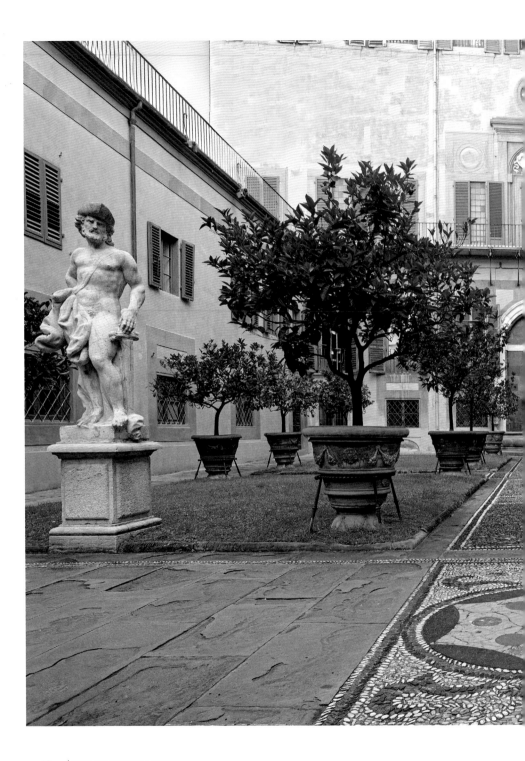

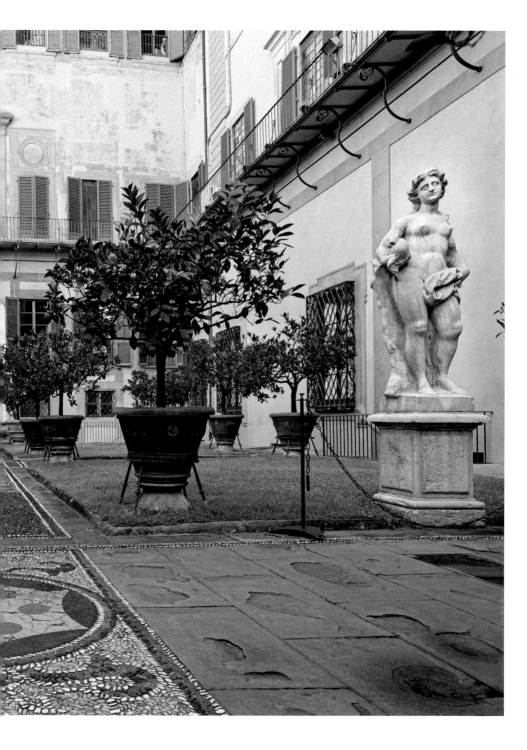

such care and good judgement that some thin, white veins inside the red stone were carved by the artisan in the exact place where tiny tendons would appear, which can be observed in real bodies when they are flayed. This must have made the statue seem remarkably lifelike when it received its first polishing. (Giorgio Vasari, *Life of Andrea del Verrocchio*, 1568).

These two celebrated classical structures, one restored by Andrea Verrocchio and the other by Mino da Fiesole, were confiscated in 1495 together with other Medici treasures, were brought back to the palazzo when the family returned to the city in 1512 and were then taken to the Casino di San Marco by Carlo de' Medici in 1621; one of the two is now in the Uffizi Gallery.

Besides the antiquities, another impressive feature of the garden was Donatello's statue of *Judith and Holofernes*. Seized by the Signoria at the end of the fifteenth century, it was placed on the *arengario* of Palazzo Vecchio, where it is still housed today. Probably executed at the end of the 1450s, it is recorded as being in the garden in the summer of 1464, standing on a high plinth and certainly placed in a strategic point, though the exact location is not known. An Old Testament heroine, Judith, is depicted in the act of delivering the final sword thrust, while holding the helpless tyrant Holofernes by his hair. In a similar way to the *David* in the courtyard, Judith also lay at the heart of a system of images with deep political and symbolic meanings, designed to associate the ideals of civic justice with the ideology of the Medici, as is clearly underlined in this case too by the two original inscriptions, referring directly to Piero the Gouty: "Salus publica. / Petrus Medicis Cos. fi. libertati simul et fortitudini / Hanc mulieris statuam, quo cives invicto / Constantique animo ad rem publicam tuendam redderentur, / dedicavit" ("The salvation of the state. Piero de' Medici son of Cosimo dedicated this statue of a woman both to liberty and to fortitude, whereby the citizens with unvanquished and constant heart might return to the republic") and "Regna cadunt luxu, surgunt virtutibus urbes. / cesa vides humili colla superba manu" ("Kingdoms fall through luxury [sin], cities rise through virtues. Behold the neck of pride severed by the hand of humility"). Also placed in the garden from 1531 was Baccio Bandinelli's *Laocoon,* now in the Uffizi, a reproduction of the antique original found in Rome in 1506. Commissioned by Pope Leo X for King Frances I of France, for Bandinelli it was an invaluable occasion to engage with the highest expressions of ancient art, similarly to what had happened with *Orpheus,* in dialogue with the *Apollo Belvedere*; when Pope Clement VII was elected, the work was transferred to Florence, put on a plinth and placed in a niche on the north wall, contributing to rendering the palace a measured Medici Belvedere, inspired by the famous Belvedere courtyard in the Vatican. It too went to the Casino di San Marco in 1621 when Carlo de' Medici moved there.

In the meantime the garden, a place of delight and amenity, had been significantly modified for the marriage of Lorenzo, Duke of Urbino, to Madeleine de la Tour d'Auvergne in 1518, which echoed the

memorable festivities of Lorenzo the Magnificent and Clarice Orsini around fifty years earlier: "the wedding banquet was held in the garden of the said palace; to organize said banquet, everything was cleared and paved with other connected planes, as these beautiful courtyards are paved today, and it is thought that it is still like that today" (Bartolomeo Masi, *Ricordanze*, 1511–1526).

Lorenzo, the duke of Urbino, who had already taken up residence in the palace with the Medici restoration of 1512, married Madeleine as part of a pro-French policy, which was further strengthened by their heir Caterina, the future queen of France. For the wedding, the garden became a paved "second courtyard", adorned with drapes and tapestry hangings and used for the wedding banquet. In the decades that followed it was also a magnificent and sumptuous setting for important wedding celebrations: Alessandro Medici and Margaret of Austria celebrated their marriage here in 1533, as did Cosimo Medici and Eleonora di Toledo in July 1539. For the latter occasion, the courtyard was essentially transformed into a room: six large paintings celebrating the glories of the house of the Medici stood along each of the long sides, while up above a ceiling of fabric simulated "a taut sky", from which small cupids descended with little lamps; the prince and his court sat in the south portico, the ladies in the centre. On the northern side a stage was set up for a performance of Antonio Landi's theatrical comedy, *Il Commodo,* preceded by an original and significant parade of 48 allegorical figures associated with Tuscany.

After the Medici court moved to the

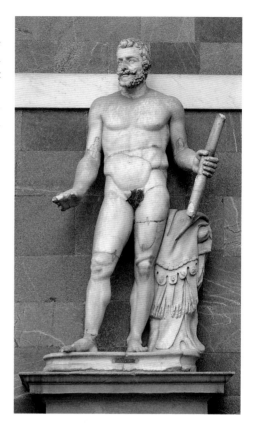

palace of civic government, now the Palazzo Vecchio, the building lost its original political salience: as mentioned, we know that in the early seventeenth century the north half of the garden, separated by a wall, was turned, at the wishes of Ferdinando I, into a construction site for marble works destined for the Chapel of Princes in San Lorenzo; while at the end of the century, following modifications ordered by the Riccardi family, the space was restored to its former function: two rectangular lawns flanked a little avenue culminating in the niche on the north end. Here, where Bandinelli's *Laocoon* had once stood, a virile marble statue was placed above the basin with a backdrop

of dark green Prato marble. The torso is Roman, probably a replica of the Borghese *Ares* (now in the Louvre in Paris), while the head and most of the limbs are seventeenth century; the markedly characterized face unquestionably portrays a Riccardi, probably Gabriello's military brother Cosimo. On the other side, in front of the Medici loggia – which in the meantime had been turned into a closed gallery – was a single rectangular lawn, with a round fountain in the middle and plant boxes on the sides. The Riccardi were also responsible for the monumental gate on via Ginori and the adjacent window.

Subjected to further changes in the nineteenth century (in 1814 there were stables with horses, a storeroom and a series of outbuildings such as a haybarn, rooms for coachmen, and one for the sale of wine), the space was included in a renovation plan drawn up by a special committee from 1911. The project was approved the following year and envisaged what can still be seen now: the fountain in front of the loggia, the division of the green areas into squares, bounded by paved walkways with decorative features in river pebble gravelling, within which the Medici and Riccardi arms in marble *commesso* stand out. Further ornamentation was provided by recipients for citrus fruits and eighteenth-century marble statues, which came from a private garden.

6 THE LOGGIA OR GROUND-LEVEL GALLERY

In the fifteenth century, there was an open ground-level loggia on the south side of the garden, and the capitals are still visible. The bridal banquet was held here when Lorenzo the Magnificent and Clarice Orsini married in 1469. Four long inlaid benches were recorded as being here when Lorenzo died in 1492; placed against the walls their total overall length was around 80 Florentine *braccia* (approximately 46 metres). And here the young Mariotto Albertinelli would find some ancient reliefs on which to exercise his hand: "he set about studying those antiquities then present in Florence, the majority and best of which were in the Medici house; and he drew many times some half-relief squares that were under the loggia in the garden towards San Lorenzo".

Emphasizing this function, when Gabriello Riccardo bought the palace he turned the loggia into a sculpture gallery, subsequently embellishing it with stuccoes by Giovan Battista and Marco Andrea Ciceri (1691–1692). Accessible only on special occasions, the predominantly white decoration has an admirable freshness and elegance, punctuating the pale green walls with pilasters, niches and aedicules that are almost rococo in taste; modelled in the centre of the ceiling, adorned with elaborate festoons of flowers and decorative features, is a stucco key, the heraldic device of the Riccardi family. We know that in the Riccardian period there were many antique marbles here: in the inventory of 1715 the space appeared to be a small sculpture

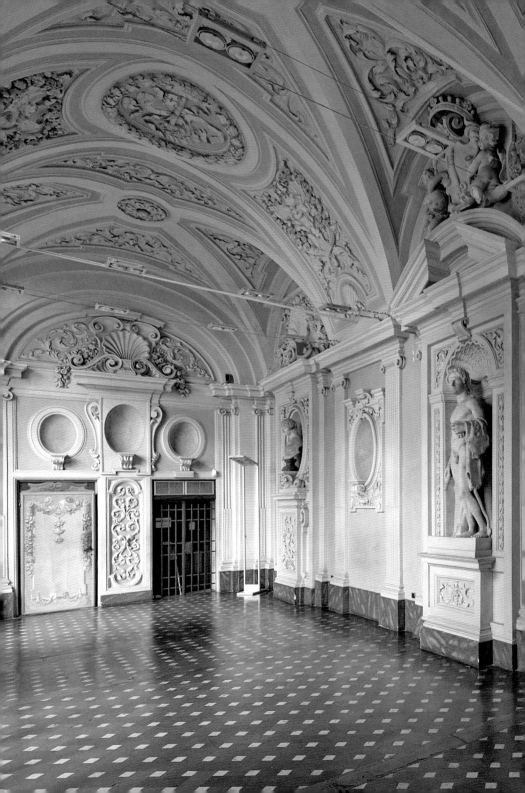

museum, with portrait heads, busts and statues. Traces of this function can still be seen in a selection of works positioned inside the ovals and niches: in the central niche is an ancient Hercules, with extensive modern additions (including the left arm with the Nemean lionskin), while to the sides there is the head of Antinous, also set in a modern bust, and two female busts, presumably modern and depicting Cleopatra and Juno.

LORENZO THE MAGNIFICENT'S HOME: THE INVENTORY OF 1492

Introducing the studies on the inventory drawn up in April 1492, immediately after the death of Lorenzo the Magnificent, Robert Stapleford observed: "Archives are like attics. We put things in them thinking we might have need of them later, and then we forget, and the years pass, until no one remembers and they undergo a kind of sea change, becoming somehow more than they were when they were new. What was mundane becomes extraordinary." The magic of an object seen and remembered after a long time recalls the surprise we might feel when walking in the footsteps of the person who undertook to inventory all the goods and objects housed in the palace of Lorenzo the Magnificent at the time of his death (Archivio di Stato di Firenze, Mediceo del Principato, filza 165 – similarly to what happened in the period of Piero di Cosimo with the inventories of 1456, 1463 and 1465). Besides the furnishings and furniture, we find a minute description of the clothes and arms contained in the house, of the rich collection of coins, paintings, sculptures (the inventory lists 139) antiquities, precious stones and jewels: everything was carefully appraised, with the overall value amounting to 79,618 florins. And so, opening up doors, wardrobes, storage chests and strongboxes together with the inventory clerk, it really feels as if we are there, hundreds of years ago. In the basement we find the cellars, accessed from a ramp on the north side; the stables were formerly here, but had already been moved elsewhere. On the ground floor, in the northern wing, were service areas, including rooms for grooms and the porter, next to the main entrance on via Larga. The chambers of the clerks were also here, where secretaries conducting the business of the Medici Bank worked under the severe gaze of "a marble head with the features of Cosimo" the Elder. In the south wing there was the first complete apartment suite, with a loggia onto the garden and an independent door leading to via dei Gori, presumably occupied during the summer. In the summer months, Lorenzo the Magnificent resided on the ground floor, in the "large ground-floor chamber called the chamber of Lorenzo" (where the ticket office is today), which had a "stove and antechamber"; here we find cypress wall panelling with inlay work, a magnificent bedstead and a day-bed, tables, cupboards, chairs and "six paintings above the aforementioned panelling and above the bedstead

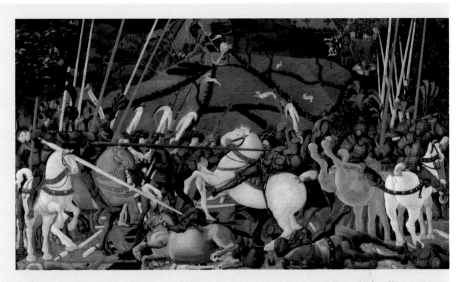

Paolo Uccello (1397-1475), *Battaglia di San Romano*, 1438. Florence, Gallerie degli Uffizi

framed all around in gold, [...] three depicting the rout at San Romano and one a battle of dragons and lions and one the story of Parios, from the hand of Paolo Uccello, and one in which is depicted a hunt by Francesco di Pesello" (f. 6r). The inventory refers here to the celebrated paintings of the *Battle of San Romano* by Paolo Uccello, now split between Florence (Uffizi Gallery), London (National Gallery) and Paris (Louvre). The battle was fought on 1 June 1432 and won by the Florentines under the command of Niccolò da Tolentino, an ally of Cosimo the Elder. In addition, there were two other works by the same artist and a hunting scene by Francesco di Stefano known as Pesellino. Also recorded as being in the same room was the *Adoration of the Magi* by Fra Angelico and Filippo Lippi (National Gallery of Art, Washington DC), the painting with the highest valuation (100 florins), and the *Portrait of Galeazzo Maria Sforza* by Piero del Pollaiolo (Uffizi Gallery, Florence).

Lorenzo's main apartment suite – and before him, that of Cosimo and Piero – was however on the *piano nobile,* above the main entrance to the palace, corresponding to the ten biforate windows looking onto via Cavour. Access was via a flight of stairs in the south-east corner of the courtyard, connected to the external loggia and ending in a passage, used only by the most illustrious guests: Galeazzo Maria Sforza, for example, was welcomed here in 1459. The grand apartment consisted of a large reception room (Sala Grande), a bed chamber, an antechamber with a mezzanine room above it, and a study. The Sala Grande, illuminated by seven windows, had a beautiful gilded and colourful coffered ceiling, with the shields of the coats of arms of Florence and the Medici family beneath. Benches and panelling with intarsia encircled the room, while great masterpieces hung from the walls the

inventory mentions three large paintings depicting the labours of Hercules (a hero strongly associated with the city) by Antonio and Piero del Pollaiolo and dating to 1460 (*Hercules and the Hydra, Hercules and Antaeus, Hercules and the Lion*); above the doors were Pesellino's *Lions in a Cage,* an echo of the Marzocco lion that is the symbol of Florence, and a *Saint John the Baptist,* the city's patron saint, by Andrea del Castagno. It was at the windows of this room, according to historians, that Lorenzo the Magnificent appeared, injured but safe, to reassure the people after the Pazzi conspiracy on his life in 1478: "nor would the people have been so contained [...] if, having gone to the house of the Medici and shouting that they wanted to see if Lorenzo was dead or alive, he, appearing at the windows with bandaged neck, had not beseeched them to curb themselves" (Scipione Ammirato, *Istorie fiorentine*, VIII, published posthumously in 1641–1647).

Adjacent to the Sala Grande, used as an audience chamber and living room, were the private rooms, that is to say, the chamber and antechamber (perhaps originally used as the bride's bedroom) with the mezzanine room, furnished with bedsteads and bed-settles, chests and panelling, *cassoni* and *forzieri* (clothes chests). Piero the Gouty had to receive the young cardinal Francesco Gonzaga here when confined to his bed for gout; in Lorenzo's time, busts of his parents (Piero and Lucrezia Tornabuoni) produced by Mino da Fiesole in 1453 were situated above the doors; while in the room, besides the furnishings, there were fine sculptures and paintings, including a *desco da parto* (birth tray) with Scheggia's *Triumph of Fame* (Metropolitan Museum of Art, New York), realized for the birth of Lorenzo and bizarre marvels like an ostrich egg and a reflecting sphere. Adjacent to the chamber was the study, a splendid treasure trove of precious items and a quiet space for contemplating the incredible Medici collections of coins, gems, cameos (the inventory lists 75!), jewels, vases and antiquities. The list of all the objects contained in the study ran to no fewer than fifteen pages, both recto and verso. Among them was the Tazza Farnese (in grey sardonyx, now in the Museo Archeologico Nazionale in Naples), valued in the inventory at 10,000 florins, and the cameo with *Noah's Ark* (now in the British Museum in London), valued at 2,000 florins. These sums appear even higher if we compare them to the cost of living at the time: at the end of the fifteenth century 70 florins sufficed to sustain a family with three or four children for a year. The study also housed various exotic objects: a horn believed to be of a unicorn with a value of 6,000 florins, and an elephant tooth.

Precious and enchanting objects, presumably stored in intarsia cupboards, above which there glowed a ceiling with enamelled terracotta tondos by Luca della Robbia, who also did the floor (the pieces now in the Victoria & Albert Museum in London were presumably part of this).

A second apartment, also on the *piano nobile,* was laid out on the south side, along via dei Gori: this had a *saletta* where family meals were eaten, a bed chamber and an antechamber, a mezza-

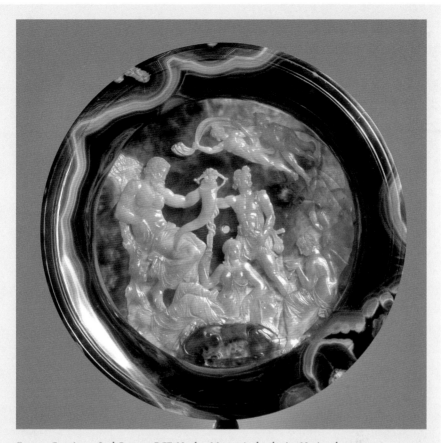

Farnese Cup, 1st or 2nd Century BCE. Naples, Museo Archeologico Nazionale

nine room and a small shrine. This suite was occupied by Lorenzo's son, Giuliano, in 1492, after his brother Giovanni, who had just become a monsignor and would later be Pope Leo X, had moved to the monastery of Sant'Antonio.

Towards the garden there was a third apartment, with a chamber, antechamber and mezzanine room, a water closet and a *munitione* or armoury, prevalently for jousting tournaments; on the same west wing there were the quiet, secluded rooms that Cosimo the Elder had kept for himself in his time and which

are recorded in the inventory as Piero's, while in the north wing there is mention of rooms for the wet-nurses and servants, the "bread room", the "fruit storeroom" and the "vinegar room".

Finally, on the top floor, there was a terrace, other apartments – not occupied at the end of the fifteenth century, apart from a room for the chaplain – and a library, unfortunately not inventoried, while under the roof there was an authentic arsenal, containing armour, lances, crossbows, harquebuses and other weapons. ▣

7 THE MONUMENTAL STAIRCASE

Retracing our steps from the garden, we re-enter the courtyard of the columns, which gives access to the first floor. The monumental staircase in the north-east corner leads to the *piano nobile* and the palace's Renaissance jewel, the Chapel of the Magi. If in the time of Lorenzo the Magnificent the chapel was accessed by walking the length of the *piano nobile*, having come upstairs from the opposite corner of the palace, it is reached from the courtyard and due to an explicit desire to preserve the space. Initially, in fact, the chapel was set to disappear to make way for the staircase commissioned by Francesco Riccardi. So we are told in the guide to Florence by Frances-co Bocchi (with additions by Giovanni Cinelli) in 1677: "the old chapel, though it will have to be demolished in order to build the new stairs, is nonetheless worthy of mention for its rare beauty." Fortunately, the project was reconsidered and the decision taken to sacrifice just a small portion in the south-west corner, moving two sections of walls and repainting a part (the one above the current entrance, the work of Jacopo Chiavistelli, the Riccardi's trusted artist), together with a series of restorations and re-paintings of the whole cycle.

In the same way as the façade extension had been executed so as to blend in with the rest of the Medici building,

the staircase (1686–1688) – the new access to the *piano nobile* – was conceived in the neo-Renaissance style, with elegant, measured structures in *pietra serena* and white plaster, niches and aedicules. Statues from the Riccardi collection were placed in the niches: on the first landing is a statue of a young man (the torso is antique, the rest is the fruit of a skilful intervention in the second half of the sixteenth century), while on the second there is one of many Roman copies of the resting satyr (*anapauomenos*) by the Attican sculptor Praxiteles, also completed in the modern age; finally, on the third landing there is a modern female statue with elaborate drapery.

8 THE CHAPEL OF THE MAGI

"Where is the child who has been born king of the Jews? For we observed his star at its rising, and have come to pay him homage." (Mt, 2, 2).

The Chapel of the Magi is unquestionably one of the most beautiful and precious places in the entire building, a gem set within an austere and grand palace. Designed for the *piano nobile,* adjacent to the main apartment of the Medici household, the small room came about after Pope Martin V granted Cosimo the Elder and his wife Contessina de' Bardi the privilege of having a portable altar in their home for the liturgy.

Work on the chapel, comprising a square room and a small, raised apse or *scarsella*, began in 1449. Apart from the series of wall frescoes, it was completed within a decade, as it had already been used as a place not just for prayer and retreat but also for the sumptuous reception of guests. The decorative scheme was extremely sophisticated: the two oculi, the only light sources originally conceived for the space, and the elegant, grooved pilasters at the entrance to the *scarsella,* were accompanied by a lavishly carved, painted and gilded wooden ceiling. The *scarsella* has the monogram of Saint Bernardine inside a garland with tri-coloured feathers and diamond rings (both Medicean symbols) on an azure ground, while the body of the chapel has four coffers in the middle surrounded by rectangular-shaped frames and rosettes. The carving, the work of Pagno di Lapo, is richly coloured and has a generous layer of gold leaf, making the ceiling one of the finest examples of its kind. Its forms and decorative richness is matched by the floor in inlaid polychrome marble, which makes extensive use of white Apuan marble, red porphyry and green serpentine (evoking majestic ancient imperial examples and attesting to the Medici's passion for semi-precious stones), punctuated by discs and geometric forms arranged according to principles of measure and proportion, aspiring to perfection.

The altar frontal, in red wavy-grooved marble, is now completed by a twentieth-century white marble shelf, while the altarpiece is a copy of Filippo Lippi's *Adoration of the Child,* produced by his own workshop. Seized from the Medici when the family were expelled in 1494,

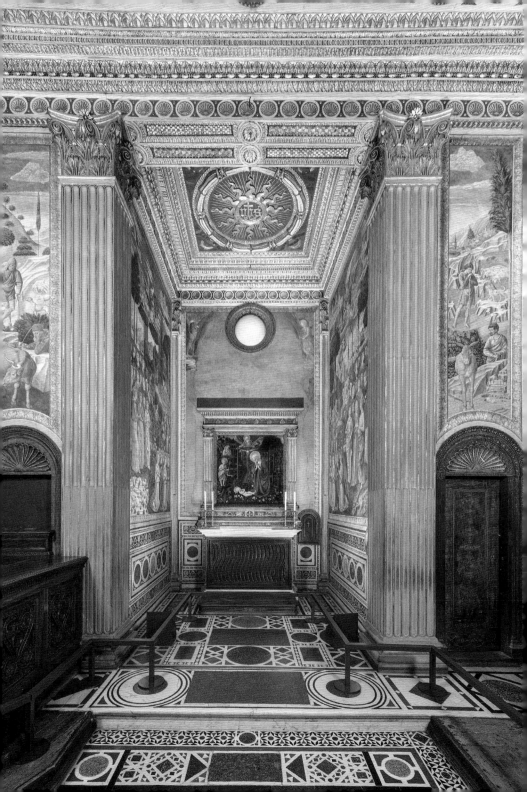

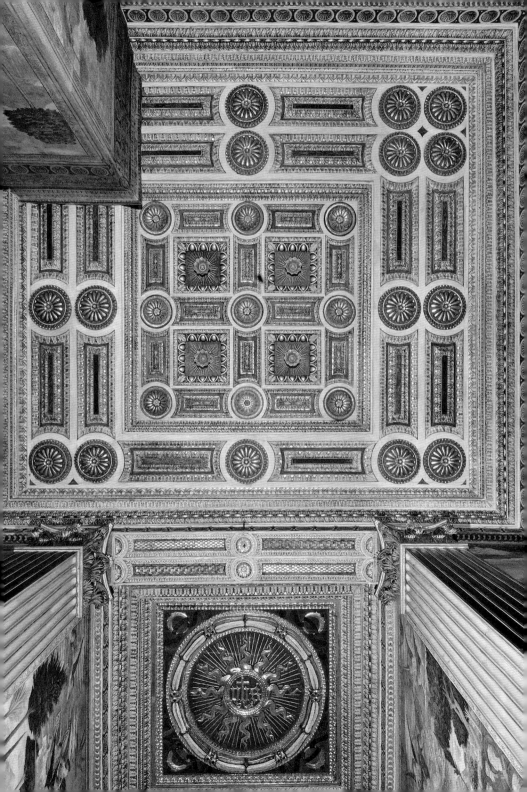

it later returned to the palace before being sold in 1814. It is now in the Gemäldegalerie in Berlin. The theological fulcrum of the entire chapel, it was already glimmering with its precious golds before 1459, when the frescoes had not yet been done and the walls were probably covered with tapestries designed to amplify the message of redemption conveyed by Lippi's work. The iconography is specific: Mary is adoring Jesus, who is lying in a patch of flower-strewn meadow, carved out with difficulty with an axe from the wild vegetation. They are under the protection of God the Father and the Holy Spirit, and in the company of Saint John the Baptist as a child and Saint Bernard of Clairvaux, a mystic father of the Church. The former is the patron saint of Florence, but the latter was also widely celebrated in the city, and the Chapel of the Priors in the Palazzo della Signoria is dedicated to him. He also staunchly affirmed the dogma of the Trinity, ratified during the Council of Florence:

Pope Eugenius had all the learned men in Italy and outside Italy come [...] to discuss these differences that there were between one Church and the other. The main one, and of most importance, was that they wanted the Holy Spirit to proceed from the Father and not from the Son, and the Roman Church wanted it to proceed from one and the other. In the end, the Greeks acquiesced to the Roman Church. (Ambrogio Traversari, from Vespasiano da Bisticci, *Lives of Illustrious Men*, 1478–1480).

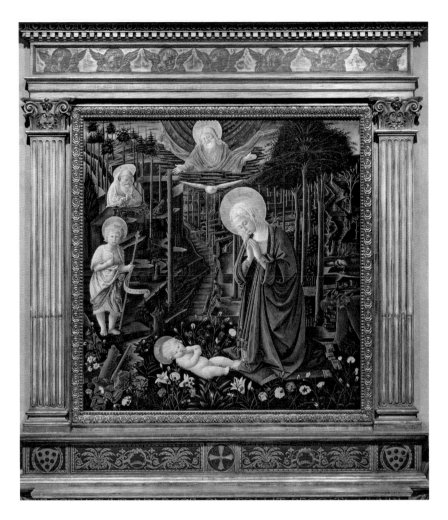

The coming of Christ instils the hope of salvation: signs of this, on the right, are the clear, limpid stream flowing in the shadows, and the stork swallowing the snake, a metaphor of victory over evil; it is the task of humans, on the other hand, to clear the trees from wild places to bring light to the path and arrive at the contemplation of the holy mystery: "enter the field of your Lord and consider how everything has now become wild, dense with thorns and weeds [...]. To work then: consider that the time to cut has arrived" (Saint Bernard, *De Consideratione*). The panel painting on display now, perhaps produced for the convent of Sant'Apollonia, particularly devoted to Saint Bernard, has a similar compositional structure to that of the original, except for the measurements, amplified in part by the festoon- and fruit-painted frame, the flatter and more luminous

atmosphere of the background and the embellishment of the garden, blooming with roses, Marian lilies and the Florentine iris, a civic symbol placed right in the centre next to the Child.

The decoration of the walls commenced in the summer of 1459. At work we find Benozzo di Lese (c.1420–1497), better known as Benozzo Gozzoli, a former assistant to Beato Giovanni Angelico and an artist gravitating within the Medicean orbit. With solid skills in the fresco technique, he was probably helped by Angelico's nephew Giovanni della Cecca. Before beginning to view and interpret the cycle we would suggest looking above the *pietra serena* cornice at the exit (the original fifteenth-century entrance): depicted here is the *Mystic Lamb* on an altar, decorated with a rich cloth, a magnificent frontal, seven candlesticks and seven pendant seals. In fact, the room originally had two entrances: one from the long passageway, accessed from the stairs on the opposite side, and used by guests and delegations; another, more private one, from the apartment chamber.

Though represented by the painter in gentle and meek forms, it is the Lamb of John's Apocalypse, an evident symbol of the judgement faced by all humans

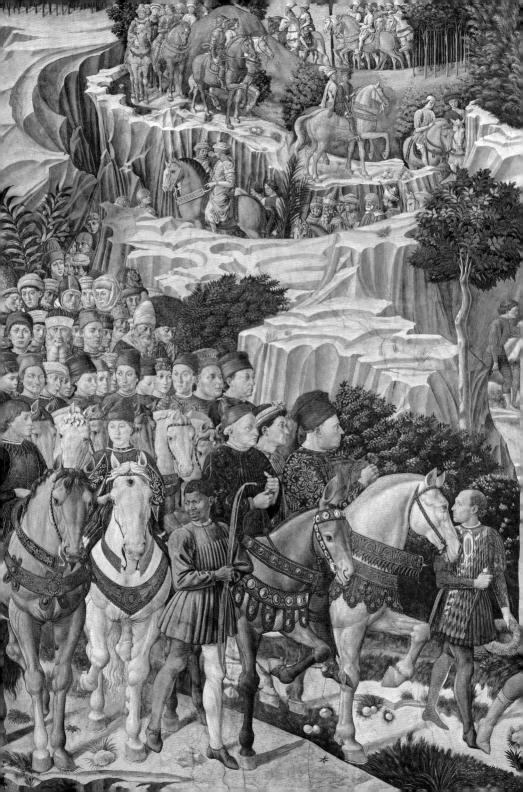

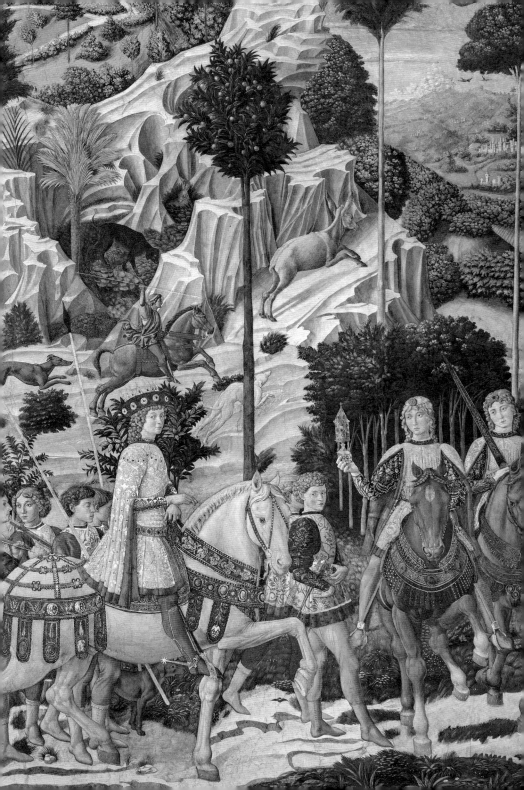

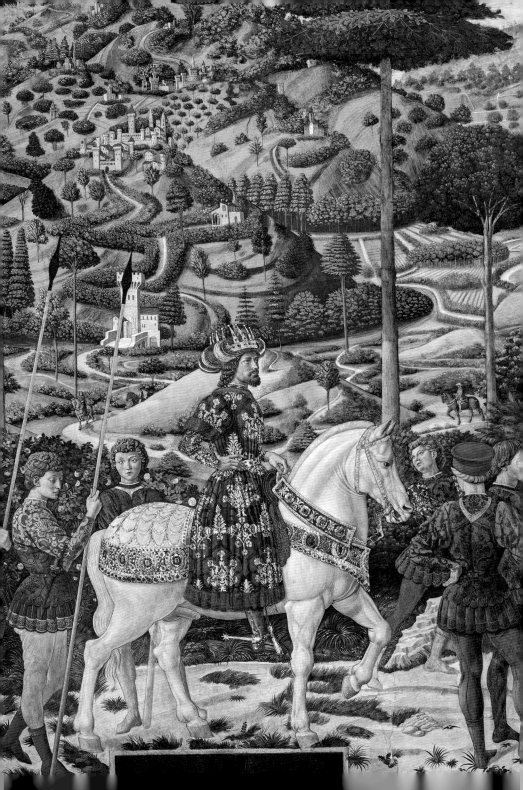

after death. Also referencing the Lamb are the four evangelists painted on the altar wall (due to the insertion of a window in the nineteenth century, later converted into an oculus, only John's eagle and Matthew's angel are visible today). In Ezekiel's vision, they accompanied the Lamb, and foreshadowed both the birth of Jesus, presented with the painting on the altar and praised by the angels on the walls of the *scarsella,* and the journey of the Magi, which unfolds along the walls of the room.

Depicted here, then, is a real journey of faith around the mystery of the Incarnation, the subject of deep debate at the council between the Western and Eastern Churches that had taken place in Florence twenty years earlier. Cosimo the Elder played a significant diplomatic and financial role in this, and the fresco cycle serves as a reminder, an important echo not just for the eastern taste of certain details and of the clothing, but above all in theological terms. According to some historians, the two older Magi, Melchior and Balthazar, allude in an idealized way to Patriarch Joseph of Constantinople and John Palaeologus, both of whom were present in Florence for the Council.

In support we have a brief text by the prelate Gentile de' Becchi, in the service of the Medici family from 1454 until his death in 1497, who at the time was tutor to young Giuliano and Lorenzo. A few years after the cycle was painted, he wrote: "Ad Cosmianum sacellum in cuius prima p[ar]te Magi in 2ª / Angeli canentes in 3ª Maria partum adorans, ut corde, v[er]bo / et op[er]e adeuntes sacrificare pingebatur" ("The chapel of

Cosimo, in the first part of which was painted the Magi, the second singing angels, the third Mary adoring her newborn Child, so visitors might sacrifice themselves with the heart, with words and with work"). Becchi also recorded the couplet present at the time above the door of the chapel entrance, which summarized the theological message underpinning the decoration: "Regum dona. Preces sup[er]um. Mens Virginis ar[a]e / Sunt sacra Siste procul turba p[ro]fana pedem" ("The gifts of the Kings, the prayers of the heavenly spirits, the mind of the Virgin are the holy things of the altar. O profane crowd, keep away").

It was, then, a layered and complex religious message, which starts with the Magi – with whom worshippers could identify in a symbolic path towards the *Adoration of Christ* – carefully depicted by Benozzo Gozzoli while on their journey. Conceived and realized in the constant half-shadow of the chapel, the procession stood out thanks to the pale, luminous colours and the gleaming gold used extensively both in the room – where it adorns not just the clothes, harnesses and objects, but also the pinkish clouds of the sky – and in the *scarsella.* It can even be found among the feathers of the wings and in the eye pupils of the angels. Fine gold and ultramarine sky blue were generously applied because of their ultramundane symbolic significance but also their high financial value, signs of regality and wealth, employed in masterly fashion by Benozzo thanks also to his early career as a goldsmith. Accompanying these colours are the extraordinarily rich velvets and leathers, clothing and

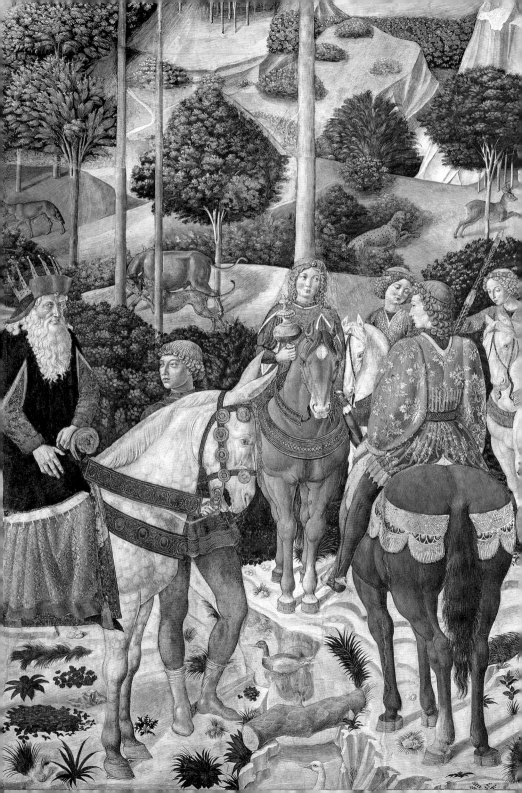

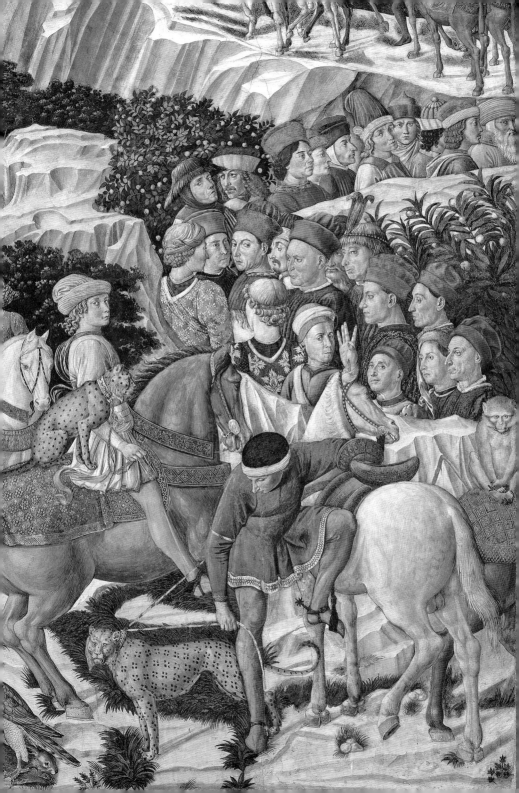

braiding, brocade and embroidery work of the figures in the cavalcade, skilfully set in a gentle hill landscape with a clear, limpid atmosphere, combining natural beauty with human industriousness. The crowd of figures are like an intarsia within the broad landscape, where rocky mountains alternate with almost abstract forms and minutely described vegetation, including shady woods and verdant expanses, tall, thin trees and leafy bushes, populated by animals represented with equal precision. It is possible to make out castles and fortified settlements, porticoed houses and stables, cultivated fields, rows of vines, pastures and canals, but also bushes and tall-trunked trees, including cypresses, holm-oaks, strawberry trees, pomegranates, oranges, cedars and palms. There is a rich and varied presence of domestic and wild animals as well, the sophisticated products of both conventional images and naturalistic representations. And though there are exotic touches, everything seems to be taking place within a broad and spectacular hunt, evoking the memorable ones organized by the Medici in the hills around Florence: one of these, led by Lorenzo the Magnificent in 1475, reputedly involved over 15,000 people.

The artist produced an exquisite synthesis between religious episode, courtly fable and Medicean presence, deploying and overlapping a multiplicity of theological, philosophical, political and apologetic meanings, which we will summarize below. The wise kings – richly dressed and with elegant radiate headdresses, each distinct from the other – are on horseback, following the star (the mysterious absence in the narrative): they are almost painted equestrian monuments, preceded and followed by a large retinue of companions, pages, servants and grooms on foot and horseback. A place of honour among them is reserved for the two riders immediately before the Magi, one carrying a sword (*spatharius*) and the other the precious gifts of gold, incense and myrrh.

The procession starts on the east wall, from a turreted white castle, perhaps an allegory of Jerusalem: Gasper advances on the east wall, Balthazar on the south wall (the one most impacted by structural modifications over the centuries) and Melchior on the west wall. All three are riding in the middle of their respective scene, accompanied by a small party, echoing the more modern Renaissance brigades, also in the strict combination of colours in the attire: white for Gasper, green for Balthazar, red for Melchior, colours referring not by chance to the theological Virtues (the white of Faith, the red of Charity and the green of Hope) and very dear to the Medici family as well.

The three-part division also plays an important role in symbolic terms, evoking the three ages of man , the phases of the day and the seasons: youth, dawn and spring for Gasper; maturity, midday and summer for Balthazar; old age, sunset and autumn for Melchior.

If Melchior and Balthazar might ideally refer to Patriarch Joseph and John VIII Palaeologus, Lorenzo de' Medici has been associated with the youngest king, Gasper: and though neither his appearance nor age support this hypothesis, it is undoubtedly possible that there is a symbolic and idealized reference to the

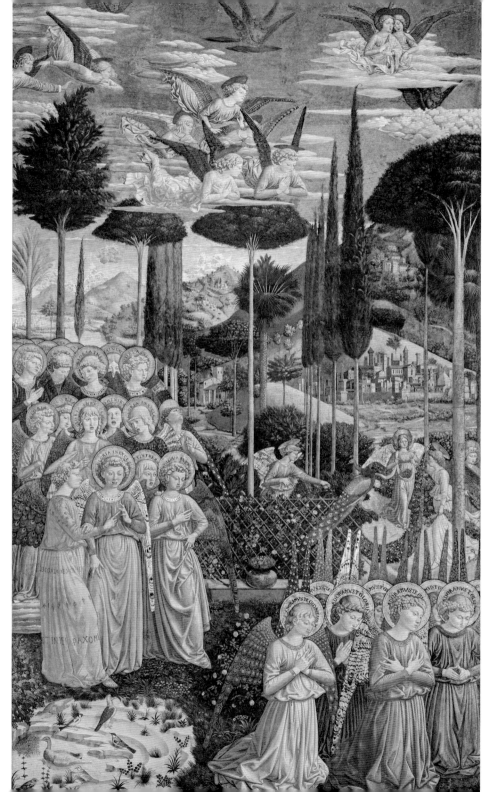

young Medici, the rising star of the family, to whom the laurel bush behind him might also allude. A faithful portrait of Lorenzo can instead certainly be found among the group following Gasper, where his distinctive face, aged between ten and thirteen, is depicted alongside that of his younger brother Giuliano. The figure standing between them may be their tutor, Gentile de' Becchi.

The fresco cycle in the chapel is in fact an exemplary prototype of a bold and previously unseen group portrait, including a plethora of scrupulously characterized figures. Though they would have been clearly identifiable at the time, they soon became unrecognizable, paving the way for as-yet-unfinished research, comparison and hypotheses. In the foreground, on the mule – which, with its slow step, is a safe and appropriate ride for the elderly – is Cosimo the Elder, accompanied by his son Piero on the white horse; between the two (or in front of them, on foot), in profile, is probably Carlo de' Medici, Cosimo's illegitimate son, while the two knights that are following have been identified as Sigismondo Pandolfo Malatesta, the lord of Rimini, and a youthful Galeazzo Maria Sforza, the first-born son of the duke of Milan, who arrived in Florence in April 1459 for Pope Pius II Piccolomini's passage through the city. Numerous other figures are crowded behind them, with very precise physiognomic features: they also include Pope Pius II, with a red mitre and a vexed expression, perhaps mindful of the modest fanfare he had received from the Medici on the occasion of his stay in Florence, about which he complained in his *Commentari*. The pope sojourned in the papal apartments of Santa Maria Novella from 25 April to 5 May 1459 while on his way to Mantua, where he had invited all the Christian princes to a conference. Illustrious lords, princes and prominent figures arrived in the city in the same days, and the fifteen-year-old Sforza had the honour of staying with the Medici.

For the occasion, the city laid on grand celebrations: a jousting tournament in Piazza Santa Croce, a dance in the square of the Mercato Nuovo and wild animal fights in Piazza Signoria, which was turned into an arena: "in Florence there had never been such a feast, nor such processions, nor such spectacles as those prepared for Pope Pius and Galeazzo Maria, the son of the duke of Milan" (Benedetto Dei, *La cronica dall'anno 1400 all'anno 1500*, c. 1475). In Palazzo Medici, a memorable banquet was organized in honour of Sforza, followed by a night-time *pas d'armes* in the streets with twelve knights, headed by an eleven-year-old Lorenzo, "upright in the stirrups, singular and rare [...] on a graceful and lovely rouncy", watched by Gian Galeazzo from the palace windows.

Sforza offers an enthusiastic recollection of his stay and of the Medici palace:

A beautiful house, for the ceilings, the height of its walls, the fineness of the doors and windows, the number and quality of the books there, the pleasantness and purity of the gardens; and so too for the tapestries with which it is decorated, the chests of incomparable workmanship and inestimable value, masterly works of sculpture and pictures of infinite kinds and even of

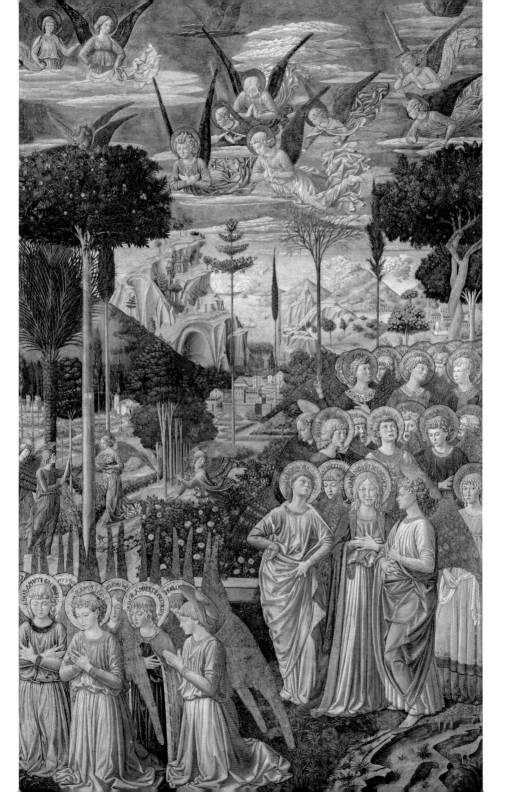

the most exquisite silver, the most beautiful I have ever seen or believe I could ever see. I went to visit the magnificent Cosimo whom I found in his chapel, no less beautiful and decorated than the rest of the house. (17 April 1459, Milan, Archivio di Stato, Ducale [Sforzesco], *Potenze sovrane*, 1461).

Returning to the portraits in the chapel, it has been suggested that the man to the left of Pius II is Michelozzo as an elderly man. One figure that has been identified with complete certainty is the self-portrait of the painter, with "OPUS BENOTII D" written on his red hat; the same image appears on the opposite wall, where the group of figures surrounding him, ready to greet Melchior, lends itself to various associations that are still the subject of debate today. What is undisputed is that they are Florentines in the service of or close to the Medici, including, for instance, the elderly Bernardo Giugni, a close friend of Cosimo's, or Francesco Sassetti, director of the European branches of the Medici Bank, or Roberto Martelli, also active in Medici affairs and with close ties to the family.

The scene is again studded with Medici heraldic insignia: the bezants or balls are alluded to in the oranges and bosses and distributed on the harnesses of the horses and the livery of the knights, as are the three-coloured feathers, the diamond ring and the motto "SEMPER".

On the sides of the altar *scarsella,* and completing the narrative, are two narrow sections frescoed with shepherds, herdsmen and their animals, captured in silent and suspended poses, in an atmosphere that is a mix of calm and expectancy: they are still unaware of the

birth of Jesus, announced to the Magi and coming to be in the altar.

This event, a cornerstone of Christianity, is also acclaimed on the walls of the *scarsella* by the choirs of angels and archangels. They are depicted circling in the sky, singing the *Gloria,* kneeling in adoration and arranging festoons and flower garlands, within a landscape that is real but seems paradisiacal:

the shady woods and flower-mantled meadows, gentle streams, clear springs and above all the nature of the places arranged for delight and pleasure. The hills seem to be laughing, and a joyfulness exuding from and spreading around them, such that anyone who sees and hears can never be sated; all this region can thus deservedly be considered and called a paradise. (Leonardo Bruni, *Panegirico della città di Firenze,* 1404).

If, among the trees in the background, there appears to be a glimpse of an idealized view of Florence, in the clear sky close to Heaven, painted with a fine ultramarine blue, the highest orders of angels circle: on both sides, there are two red seraphim burning with love and a blue cherub steeped in wisdom. These figures were the subject of correspondence between Benozzo and his client, Piero de' Medici, who was initially doubtful about the presence of the seraphim when he saw them briefly in Florence in July 1459, when the work was under way: we do not know if they were covered by dry-painted clouds, subsequently lost, or whether Piero himself changed his mind and put up with them, perhaps due in part to the

intercession of Roberto Martelli, who supervised the painting work in Piero's absence: "in my opinion they are not bad there [...] I would leave them be until your return".

The wooden choir, with richly carved and inlaid stalls, divided by volutes, is attributed to Giuliano da Sangallo and dates to the early 1470s. Originally it ran along all the walls and had a baluster parapet; it was confiscated when the Medici were driven out in 1494, restored to them upon their return in 1513, tampered with again and decorated during the modifications made by the Riccardi, and even partially dispersed (two stalls are in Vienna and Berlin). Today we can admire eight stalls on the right and just one on the left.

A further important consideration regards the tie between the city of Florence, the cult of the Magi and the Medici family. While there was no lack of artworks on this subject throughout Renaissance Italy, it is indisputable that some particularly shining examples were to be found in Florence – to mention just one, the dazzling altarpiece of Gentile da Fabriano, commissioned by Palla Strozzi now in the Uffizi Gallery – and that the city was strongly attached to this cult and celebrated Epiphany with particular intensity:

On the sixth of January a solemn and magnificent feast of the holy Magi and of the Star was held in Florence at the church of the friars of San Marco. The Magi went all round the city, very honourably dressed and with horses and with much company and with many novelties. King Herod was at San Giovanni, on a well adorned stage with his people. And passing by San Giovanni they went up onto the stage where Herod was and then talked about the child they were going to adore and promised to return to Herod. And having made their offerings to the child, and not returning to Herod, Herod persecuted and had many pretend children killed in the arms of mothers and wet nurses, and with that the feast finished in the evening at the 23rd hour. (*Alle bocche della Piazza. Diario di anonimo fiorentino*, 1382–1401).

As early as 1390, then, there is a record of the feast of the Magi taking place in the city with a solemn cavalcade. From

1417 there is documented evidence of the Compagnia dei Magi, charged with organizing the event, which grew in pomp and prestige over the years (in 1429 there were over seven hundred horsemen in the parade). Cosimo the Elder and the members of the Medici family played a very important role in this. In the 1430s Cosimo was behind the renewal of the convent of San Marco, where the company would be based; significantly, the church was consecrated on the day of Epiphany in 1443 by Pope Eugenius IV, who was close to Cosimo. We know that Cosimo himself, his children and his associates would be patrons, organizers and prominent figures of the feast of the Magi. Over the years the event became ever more splendid, a scenographic and spectacular celebration of the idea of sovereignty and of exquisite regality, of which the chapel is a fabulous and enduring manifestation.

9 THE SALA OF CHARLES VIII AND OTHER ROOMS

Exiting the chapel, we find ourselves in the passageway. Surrounding Gozzoli's *Mystic Lamb* are later frescoes, commissioned by the Riccardi family and painted by Jacopo Chiavistelli. From here there is access to the Sala of Charles VIII, occupied by the prefecture. The name of the room recalls the time Charles VIII of Valois spent in the palace, following the expulsion of the Medici, and his stay in the city at the end of 1494. This is the room where Charles apparently met the Florentine Pier Capponi:

[while] discussing among the parties the quantity of money demanded, and as it seemed to the king that the city did not satisfy what in his view was due, outraged and angry, he said threateningly: I will sound the trumpets [to order his troops into the city]. At these words, Piero di Gino Capponi, one of the delegates, with equal boldness and constancy of spirit, tearing up the copy of the articles [of peace] he was holding in his hand, replied: And we will ring the bells. Having said this, he and his companions turned round and went towards the stairs. But having called them back [...], the king said, smiling: Ah Ciappon Ciappon, you are a bad Ciappon. And so the articles of peace were prepared peacefully and happily. (Iacopo Nardi, *Istorie*, I, 1553–1563).

This area, the vestibule opposite and the room we are in were formerly occupied by the apartments first of Piero the Gouty and then of Lorenzo the Magnificent, clearly described in the 1492 inventory. The Riccardi made structural changes to the rooms: the large Sala, which in the fifteenth century was in a corner position between via Larga and via dei Gori, was shifted slightly to the north so as to be central with respect to the original façade, and in order to carve out a vestibule when arriving from the spiral staircase; it was also raised by about three metres and given a new coffered ceiling; realized between 1662 and 1664 by Luca Boncinelli and Antonio Montini, it was decorated with

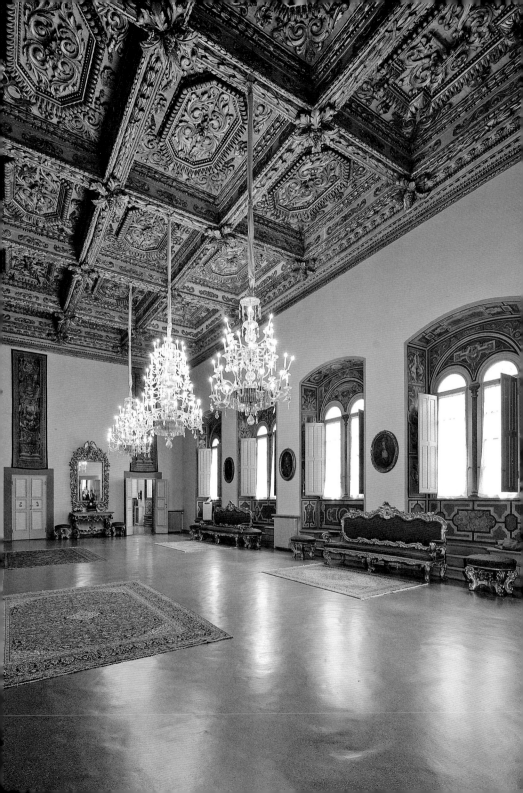

acanthus leaves and the Riccardi arms, a key on an azure field. The splays of the windows and the frieze have nineteenth-century decorations by Gaetano Bianchi (1875–1876), with classicizing and fantastic motifs.

The room and the following ones were, and still are, reserved for visits by the president of the Italian Republic: they are furnished with damask seating, mirrors and consoles, elaborate chandeliers, tapestries and paintings.

In the first room is a fine seventeenth-century *Still Life,* while in the centre of the vault there is a female allegory, presumably *Fortitude,* surround-

ed by grotesque decorations that pay tribute to Medici times, with the family shield and the sprouting *broncone*. On the left wall is a tapestry depicting the scene of John the Baptist being seized on the orders of Herod Antipas.

The decoration of the next small room, called the "painted vestibule", celebrates the marriage of Cosimo Riccardi and Giulia Spada in 1692, with the coats of arms of the two families in the corners, supported by telamons within architectural square panels. This work was carried out by Jacopo Chiavistelli as well. Between the two doors is a male marble loricate bust, perhaps pseu-

do-antique, from the Riccardi collection. The size of the space recalls the ancient *studiolo* of the Medici, adjacent and incorporated into the previous room.

The next room is distinguished by a large seventeenth-century tapestry of the Gobelins manufactory, which reproduces one of the scenes frescoed by Raphael in the Vatican Museums, namely Constantine's speech to his generals before the battle of the Milvian Bridge; in the sky above is the auspicious sign of the cross, accompanied by the Greek inscription EN TOUTOI NIKA ("in this sign you win"). In the same room there is a *sovrapporta* tapestry produced towards the end of the seventeenth century by the Medici tapestry factory to a design by Alessandro Rosi and depicting *Saint John the Baptist.*

The corner room is still furnished as a bedroom (among the furniture mention must be made of the eighteenth-century chest of drawers), and features a painting of *Saint Augustine in his Study* and a plaster relief, originally polychrome and gilded, depicting the *Madonna and Child with Angels.* This is an early twentieth-century cast of the marble work by Agostino di Duccio now in the Bargello.

In the rooms that follow are some imposing portraits of Medici grand dukes, produced between the seventeenth and eighteenth centuries in the ambit of a full-scale and unwavering policy of promoting the family image. The series was sent to the palace in 1914 by the hospital of Sant Maria Nuova as a first lot of items for the nascent Medici museum: the grand dukes are depicted full size, with crown, sceptre, gilded damask attire, ermine cloak and curtains in the background, in line with the classic composition of official portraits.

In one room is *Cosimo I* and *Francesco I* by Anastasio Fontebuoni, while *Ferdinando I* is the work of or a copy after Domenico and Valore Casini, Medici portraitists of the first half of the eighteenth century. Here some books and manuscripts from the Biblioteca Moreniana are displayed in cabinets on a rotating basis. In the following one is the full-figure portrait of *Cosimo II Medici;* smaller in size are the eighteenth-century half-bust portraits of *Francis Stephen of Lorraine,* into whose hands the grand-ducal crown passed with the death of the last Medici, and, above the passageway door, of *Maria Luisa of Bourbon,* the wife of Peter Leopold, who succeeded as grand duke. Also on display here are a tapestry depicting *Divine*

Hope and two column pairs, produced by the Medici tapestry factory at the end of the seventeenth century (to designs by Alessandro Rosi, store of the Florentine State Galleries): the first ones with candelabra motifs, and the second with olive tree trunks and the Medici arms.

The same room also houses a sculpture depicting the *Old Law,* the pendant piece of the *New Law,* now in the Museo Nazionale del Bargello. It was executed in the 1570s by Domenico Poggini: the life-size female figure is wearing a light dress and a heavy coat, with the tablets of the law of Moses in her hands. The following large room – which, on the vault, has a fresco painted by Anton Domenico Gabbiani in 1692 depicting *The Fine Arts Elevated to Immortality,* within an elaborate stucco cornice by the Ciceri brothers – houses the portraits of the last Medici grand dukes: we can once again see *Cosimo II,* by Tiberio Titi, followed by *Cosimo III* by Baldassarre Franceschini known as "il Volterrano", and *Gian Gastone* by Giovanni Gaetano Gabbiani.

Among the religious works in the same room there are two sculptures depicting the *Virgin and Child,* both seventeenth century: one is marble, where Mary, enveloped by abundant drapery, is resting her feet on the clouds, and is in turn positioned on the carved and lacquered wooden base; the other, larger one is in polychrome wood.

On the walls are the following paintings: a *Virgin and Child, Saint Anthony Abbot and a Saint* (c.1570); a small *Virgin and Child,* painted in oils according to the Byzantine iconographic tradition and topped by a panel with the *Adora-*

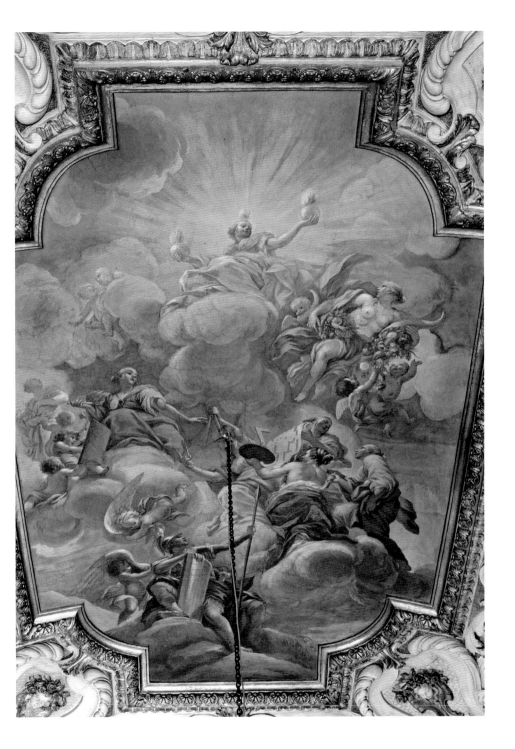

tion of the Child Jesus, the work of a late fifteenth-century Florentine master; a painting of *Mary, Jesus and Saint John the Baptist as a Child* from the first half of the sixteenth century, attributed to the workshop of Giovanni Antonio Sogliani – in turn, a pupil of Lorenzo Di Credi – due to the evident similarities with the artist's painting now in the Museo del Cenacolo in San Salvi; finally, a detached fresco representing the *Ascension of Christ*, inside an illusory gilded frame with volutes, probably from the villa of Castel Pulci. Beneath it is a beautiful carved and lacquered bench with the Riccardi crest.

FILIPPO LIPPI'S *MADONNA AND CHILD*

The place of honour among the works with a Marian theme is reserved for Filippo Lippi's *Madonna and Child*. The painting, which dates to the 1460s, was found in 1907 by Giovanni Poggi in the Florence hospital of San Salvi, and was taken to the palazzo the following year, the hypothesis being that it was a Medici commission. Supporting this supposition was the fact that the panel came from the villa of Castel Pulci, owned by the Riccardi, who may have inherited the painting as part of the palace furnishings. The work echoes one of Lippi's compositions and the Florentine Renaissance in general. Inside a marble aedicule with a shell-shaped niche, the scene depicts a close, tender and complicit embrace between Mary and Jesus, standing on a baluster cheek to cheek with his mother, who is supporting him. On the rear of the painting is a sketch of a small tabernacle and studies of a male head and eyes, executed with a brush.

A lapsed friar and an eccentric artist, Fra Filippo Lippi was the son of a poor butcher from the *oltarno* (the southern side of the river Arno), who entered the convent of Santa Maria del Carmine and soon became an admired painter with important public commissions, despite the licentious transgressions from his religious life, which led to him dissolving his vows thanks to the intercession of Cosimo the Elder. Indeed, his life and works are closely bound up with the Medici family: besides the panel for the palace chapel, mention must be made of a fine *Adoration of the Magi* tondo attributed to Beato Angelico and Lippi (National Gallery of Art, Washington DC), and two lunettes depicting the *Annunciation* and the *Seven Saints*, now in the National Gallery in London. He is said to have once given a famous reply to Cosimo, who had shut him up indoors to make him finish a painting without distractions, prompting him to escape from a window. In so doing, he affirmed both the freedom of the artist and the value of a work as a mirror of the divine: "He [Cosimo] was accustomed to visiting him every day; not finding him, he was displeased and sent for him to be found. But then he left him to paint at will, whereupon he was quickly served. He [Lippi] said that, in his view, rare and sublime geniuses are celestial forms and not pack animals." (Matteo Bandello, *Novella* LVII, 1554). ◼

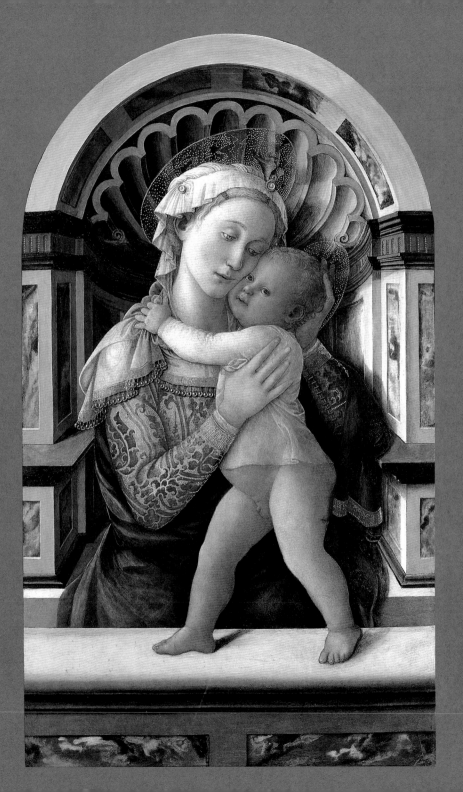

We now come to the room of the bas-reliefs: the vault is adorned with fantastic stuccos with plant motifs, executed by the brothers Giovan Battista and Marco Andrea Ciceri (c.1692) and "rendered gold" by the gilder Domenico Gori. On the walls, opulent Baroque frames enclose thirty-one antique and pseudo-antique bas-reliefs of various sizes, largely from the Riccardi collections. As mentioned earlier, in 1687 Francesco Riccardi requested and obtained permission to move the family's incredible collection of antiquities here from Gualfonda, where it had been legally bound to stay by his ancestor Riccardo Riccardi. The Baroque taste displayed by the Riccardi in the decoration of the rooms, with frescoes and stuccos of a modern and aristocratic flavour, stand alongside antiquities collected over the course of almost a century. From then on, and for many years thereafter (until 1719), a complex programme was pursued for placing and arranging them: among the first to be positioned were the bas-reliefs, which were reordered, framed and put in place in the gallery vestibule. Of the thirty-one reliefs now present in this room two are from the classical and Medici age. They had formerly belonged to the collection of Lorenzo the Magnificent, in whose time they were set in the wall of the garden loggia, where they became the subject of Mariotto Albertinelli's drawing exercises. The works depict a *Hunter* (which appears a second time in the room, in the form of a stucco cast) and a *Mythological Scene with Two Heroes,* both of which are positioned on two of the eight re-

liefs crowning the doors and windows of the room, in lavish Baroque frames: "one is Adonis with a beautiful dog, and in other [there are] two nudes, one sitting with a dog at his feet, the other

standing with crossed legs and leaning on a stick, which are marvellous" (Giorgio Vasari). A further relief is partly antique, depicting an *Erotic Scene,* and can be found on the west wall, while the others date to the sixteenth and seventeenth century: among these are "fourteen heads in white marble bas-relief joined in octagonal surfaces of Bardiglio [marble], all companion pieces". They are the profiles of emperors, divinities and warriors mounted on a dark back-

ground, probably by Orazio Mochi, a tenant of the Riccardi at Gualfonda, and the *Labours of Hercules,* now seven in number (three others are in the Bargello); distributed across two walls, and also from Gualfonda, they may have been produced in the workshop of Bartolomeo Ammannati, who was based there at the time of the previous owner, Chiappino Vitelli, a *condottiero* in the service of the Medici. These depict *Hercules and the Centaur Nessus, Hercules and Antaeus, Hercules and the Erymanthian Boar, Hercules and the Cretan Bull, Hercules and the Lernean Hydra, Hercules and Cacus, Hercules and Atlas.* Above the door and window frames there are more mythological subjects:

Youths on Horseback and Youths around a Tripod, a *Sacrificial Scene* and *Vulcan's Forge,* from Ammannati's workshop, followed by *Galatea* (A) and the *Rape of Europa* (B).

Also inventoried here from the end of the seventeenth century are three antique Roman statues, copies of Greek originals. All-round life-size works, they are on pedestals in gilded wood: an *Apollo Sauroctonos* (that is, Apollo about to catch a lizard) with a satyr head, a *Victory* and a graceful *Dancer*.

In the room, there is also a reference to more recent history, namely the bronze bust of the Italian politician Sidney Sonnino (1874–1922). Produced in 1924, it has the following inscription:

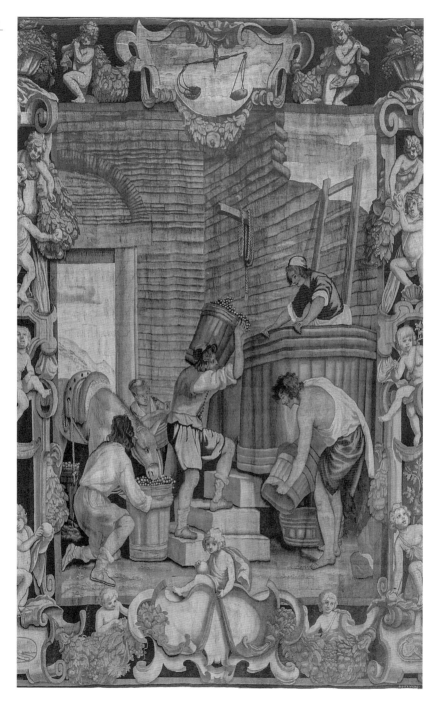

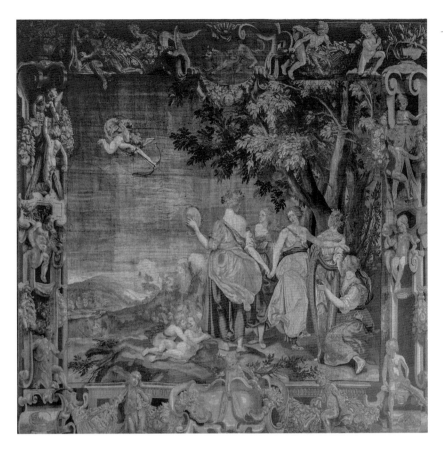

36 years on the council of this province and 42 in parliament. An example of austere character, he will live on in history because he showed our war to be just, averted the oblique manoeuvres for a peace damaging to us and, alone, defended the legitimate Adriatic border with passionate tenacity, whence many sorrows for him. But for Italy there will come one day new power and new glory. 24 May 1924.

Next door is the room of the Four Seasons, where the Council of the Metropolitan City meets. The room gets its name due to the presence of four Flemish tapestries (1641–1643) depicting the *Seasons;* woven by Pietro van Asselt to a design by Jacopo Vignali, they were brought here from the state storerooms in 1910. Starting from the left, we can see *Autumn* (c), with a group of men pouring grapes into vats, under the star sign of Libra; *Winter,* characterized by the gathering of slabs of ice from the river and by the sign of Pisces; *Spring* (d), with female figures playing music and dancing under the sign of Taurus; and finally, *Summer,* distinguished by the seasonal labour of reaping and fishing, and by the sign of Leo.

This is one of the most significant areas of the entire palace. Its construction and decoration date to the Riccardi commission: both the gallery and the library were built between 1670 and 1677 as part of a new western wing together with the extension of the façade and the building of the corresponding section on via Larga. The gallery and library are in fact the outcome of a coherent project designed to equip the palazzo with two large reception spaces within a Baroque aristocratic residence: they comprise two parallel blocks, apparently separate but actually connected by two passages hidden among the painted mirrors and cupboards of the gallery's right wall.

The works were overseen by the architect Pier Maria Baldi and then by Giovanni Battista Foggini; the space was complete by 1677. The vault was the shining culmination of a dazzling and spectacular decorative programme: it was the fruit of the wishes of Francesco Riccardi, the inventiveness of Alessandro Segno, his tutor and travelling companion but also the secretary of the Accademia della Crusca, and the hand of Luca Giordano (1634–1705), who was already working on it in 1682 and then, definitively, from April 1685, following his return from Naples.

All the decoration, conceived as a continuous, crowded and animated composition, and as a illusionistic challenge in the absence of any architectural score or stage setting, is a resounding story of myths. It acquires rhythm through the cardinal Virtues in the corners and culminates with the celebration of the Medici (for whom the Riccardi expressed great appreciation) in the centre, against a pale ultramarine azure background. The fulcrum of the whole decoration is the *Apotheosis of the Medici* in the middle of the ceiling, while unfolding around it is a rich allegorical narrative with a specific iconography drawing both on classical mythology and Christian doctrine. The intent was to extol not just the Medici but also the Riccardi and, above all, a teleological vision aspiring to virtue and knowledge. The values of discovery, of knowledge and consequently of wisdom, seem in fact to underlie the whole decorative programme, which contemplates tradition, religion and science and looks to modernity as well. One of the mottos in the scrolls arranged along the walls beneath the *cornicione* is emblematic in this sense: on the north wall, beneath the god of silence, Harpocrates (who is holding a finger to his mouth), and the god of mockery and blame, Momus, we read: "SAPIENS DOMINATUR / ET ASTRIS", "the wise man dominates even the celestial bodies". Formerly the words of Ptolemy, and cited by Saint Thomas Aquinas, here it invokes the human journey towards knowledge. This is reinforced by the way in which the Riccardi, who commissioned the work, are celebrated above the entrance on the east end: here we find *Minerva as Protectress of the Arts and Sciences,* or the *Triumph of the Riccardi:* Minerva, the goddess of wisdom – who has given her arms to a putto while Mercury offers her the caduceus and a golden trumpet – hands a key to Ingenuity (accompanied by Naked Truth) and a hammer

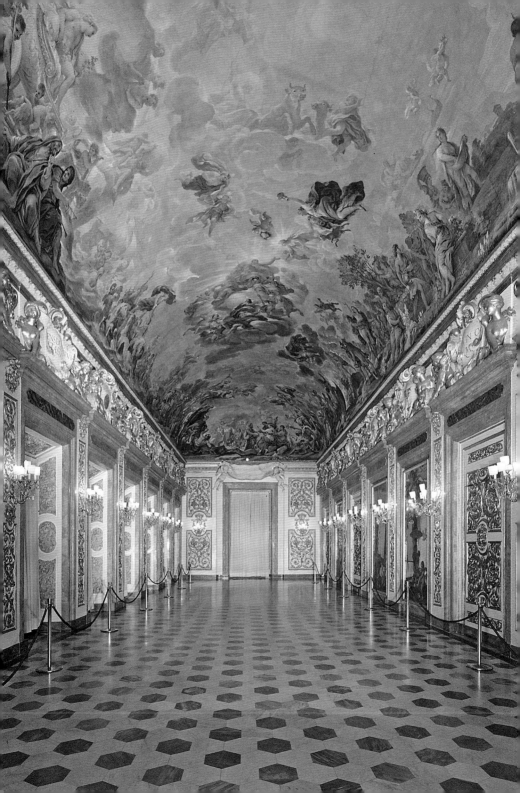

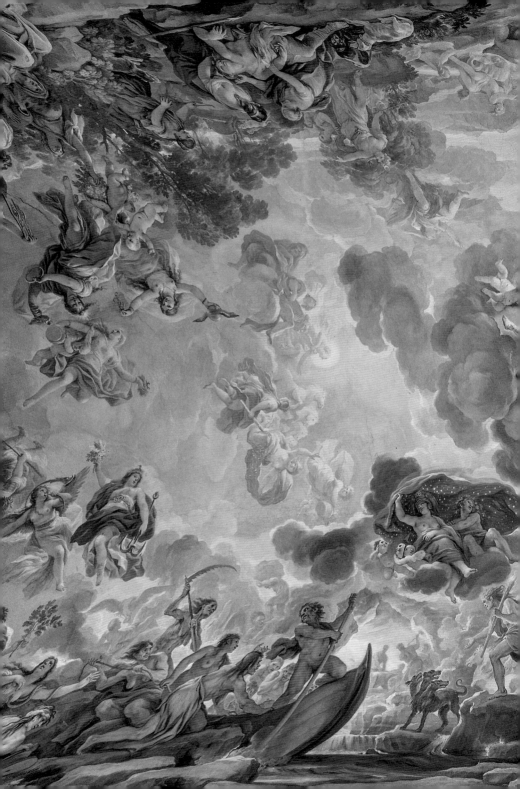

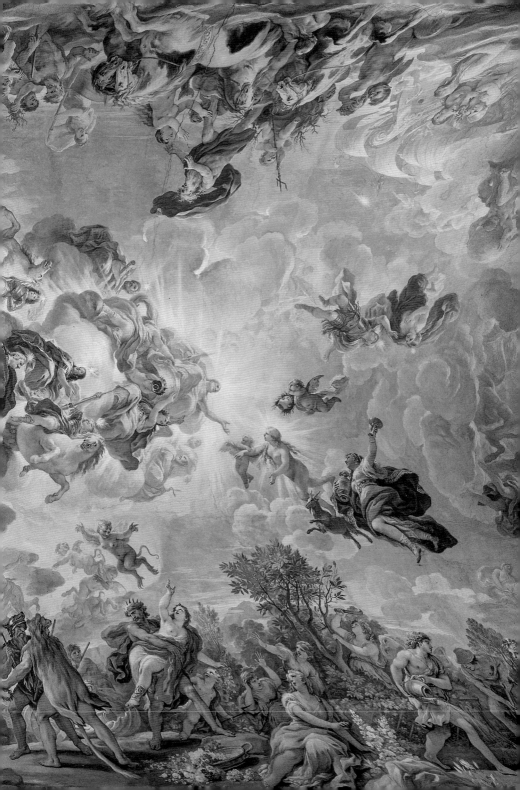

to Artifice and Industry, allegories of industrious activity, to which the beehive and the tools on the ground also allude. The key refers to the coat of arms of the Riccardi, here manifestly celebrated for their intellect and work.

Situated at the corners of the vault are the four Cardinal Virtues. They are flanked by complementary qualities, but also by the Vices opposed to them and underpinning human action in the world, which is articulated over the rest of the ceiling with human paths and destinies towards both good and evil.

On the west side, opposite the entrance to the Sala, are Justice and Temperance. Justice is on the right, with a sword and scales, flanked by Clemency and Security as she receives the crown from Good Fame. Sitting on the rock be-

low are Punishment, depicted as a man with a staff and a sword, and Premio, with a cornucopia of treasures. Also appearing here is an ostrich, because, as Cesare Ripa, the author of the celebrated *Iconologia* (1593), notes: "one must not fail to examine and unravel with a patient spirit the matters brought to justice, however intricate, just as the ostrich digests iron even though it is a very hard material". Lying on the ground are Deceit – in the company of a tiger which, by "hiding its head and displaying its back, delights with the beauty of its skin various wild beasts, which then, with a sudden movement, it takes and devours", and with a net, some hooks (to capture souls) and a bunch of flowers concealing a poisonous snake – Discord (fanning the flames of the fire with the

bellows) and Conflict, holding a snake.

On the left is Temperance, with a brake and a clock in her hands (symbols of her capacity for moderation) and an elephant (considered to have a moderate diet) at her side. Hovering above are Tranquillity, Youth and Voluptuousness, while below there are Modesty and Sobriety, the latter dominating a sea creature and holding a golden key. Lying on the ground are Sloth (or Poverty), Envy, with hair in the form of snakes, and Hunger.

In the opposite corners, on the east side, are Prudence and Fortitude. On the left, as one looks, we find Prudence, with the classic two faces and a gilded helmet on her head, a looking-glass and an arrow with a sea fish. The animal associated with her is the stag, able to run

but also to brake in order to avoid getting its antlers stuck in branches. Hovering above are Abundance (or Happiness), with a cornucopia and caduceus, Grace, Well-being with a cup and serpent, while sitting down below are two learned figures of antiquity with books and instruments. On the ground are Fraud, double-faced and rapacious, and Ignorance with an ass's head.

On the right, finally, is Fortitude, armed with a spear and shield, flanked by a lion and by Constancy (with her hand on a burning brazier); above her is Honour (who is handing her a crown of laurel) and Victory, sitting on a globe and in the act of offering her a pomegranate, while Peace descends from the sky with an olive branch and a torch to burn weapons. In the foreground

are Courage, represented as an archer, with, on the ground, a fox trampled by a winged putto; Misery; and Fear, huddled under a deer's skin.

Unfolding across the walls is a lively allegorical narrative of human life: the mythological representations refer to the four elements, the rhythms of time (of the day and of the year), but above all to the ages of the human being and their immoral or virtuous behaviour. The scenes, accompanied by scrolls with heraldic devices and explanatory Latin mottos, define an eschatological path from life to death. The representation starts in the centre of the west side, with the *Beginning of Life* or *Cave of Eternity,* enclosed by the snake (*ouroboros*) biting its own tail, a symbol of eternal time: in the background is a cave where Time sits, while in front of him a veiled divinity – perhaps Necessity – is offering a staff to blindfolded Fortune and a golden ball to Nature, who is squirting milk from her breasts. Alongside, the god Janus, bi-fronted, hands the three Fates the fibre of human life, to spin and cut. All around are numerous putti, with and without wings, representing human souls.

Continuing on the south side (on the left when entering the gallery), we find the *Death of Adonis* during the boar hunt, an echo of youth and Spring, followed by *Neptune Greets Amphitrite,* a sign of flowering love and of Summer, associated with the element Water. The next episode, *The Triumph of Bacchus,* echoes Autumn and leads to maturity; in the middle ground, the winds blow-

ing against the ship of the Argonauts re-
fer to the adversities of life and the globe
that Atlas hands to Hercules represents
the responsibilities associated with it.

Along the opposite wall are *Labours
in the Fields,* under the aegis of Triptol-
emus, Vertumnus, Pomona, Zephyrus,
and Ceres and Juno in chariots: the el-
ement alluded to is Earth, the time is
that of the whole year, which follows
that of nature. Then comes the *Abduc-
tion of Proserpine* by Pluto, with the
forced marriage and entry into the un-
derworld: the Furies, the dog Cerberus,
Carontes on the boat, Death with its
scythe and dead souls all appear, while
in the background there is a glimpse of
Vulcan's forge. The element is Fire, the
season Winter. Night flies above, pro-
tecting Sleep with her mantle of stars,
while the masked putti with butterfly
and bat wings symbolize Dreams.

On the east-end wall is *Minerva as
Protectress of the Arts and Science,* or *The
Triumph of the Riccardi,* while the centre
of the vault is reserved for the celebra-
tion of the Medici family (to whom the

Riccardi are grateful), presented as full-
blown celestial bodies. The heart of the
invention lies in fact in the satellites of
Jupiter (the *Medicea sidera*), which Gal-
ileo had discovered in 1610 and which
are the epicentre of the scene, with Ju-
piter surrounded by six members of the
house of Medici. They are distinguished
by stars on their foreheads and are vari-
ously identified: on each side of Jupiter,
almost evanescent, there would seem to
be Cosimo I on the right and Francesco
I on the left; beneath, in the centre, Fer-
dinando II with a club and lion; beneath
him is Cosimo III, enveloped in a red
cloak and in the act of tempering a hot
iron in water; to the sides, on horseback,
are the two younger princes, Ferdinan-
do and Giangastone.

Everything is rendered in Giorda-
no's fresh, lively style, in that "maniera
allegra" that made him famous, and
which has given us one of the highest
achievements of Florentine Baroque. It
continues to amaze and envelop us, just
as it did the first guests in the gallery.

Following the completion of the

OBVIA IN LABORE
FELICITAS

vault, work continued on the rest of the room: the gallery, lit by eight French windows looking onto the garden, displays a rich and imaginative profusion of Baroque stuccos and decorations. Beneath the *cornicione* are scrolls with inscriptions and Latin mottos, referring to the vault and supported by pairs of harpies and putti; on the north side, in elegant bordering in yellow Siena marble, are lavishly carved and gilded mirrors, doors and cupboards, adorned with festoons and stucco frames that are imaginatively replicated in the window splays. The decoration was once again the work of the stonemason Agnolo Tortoli; the stucco artists Giovan Battista and Marco Andrea Ciceri, and Anton Francesco Andreozzi; and the gilder Domenico Gori. The four large painted mirrors, truly unique for Florence, are the work of Bartolomeo Bimbi (flowers and fruits), Pandolfo Reschi (animals and marsh grasses) and Anton Domenico Gabbiani (putti); four pieces – like the elements, virtues and seasons – painted in a masterly fashion on glass brought specially from Venice.

By 1689 the gallery was almost complete, barring some furnishings and the built-in wall cupboards, destined to house the most precious items of the Riccardi collections of antiquities, vases, ivories, gems, medals and coins, "most rare for the quality, size, relief, carving and workmanship of those jewels".

In the meantime, Luca Giordano had frescoed the area mirroring the gallery, namely the library, with decoration appropriate to its function. The gallery and library were two very important components in the Riccardi's project to

renovate the palazzo, which acquired an increasingly modern and grandiose character, an echo of the sumptuous palazzos of the great Roman families. In January 1689 the Riccardi had already been able to organize a lavish reception for the marriage of Ferdinando de' Medici and Violante of Bavaria; from that moment on the gallery and library became perfect settings for hosting the greatest events in the palazzo and for receiving the most illustrious guests. For instance, in 1709 a magnificent reception was held for the king of Denmark and Norway, Frederick IV, who greatly admired "the beautiful Gallery, where, after viewing those charming paintings, he wanted to see the medals and cameos kept in the cupboards of the same room and saw them all at leisure" (Giovan Battista Casotti, *Diario della permanenza in Firenze della maestà del re Federigo IV di Danimarca l'anno 1709*). Luxurious celebrations continued throughout the eighteenth century: in May 1789, when Archduke Ferdinand of Austria and his wife Maria Beatrice d'Este were staying in Florence, an extremely lavish reception was laid on in the presence of Grand Duke Peter Leopold of Lorraine and his first-born son Francesco: the festivities on that occasion were described as "prodigious"; on the night of 21 May more than 4,000 invited guests crowded the palazzo, and sumptuous banquets were held, "including milk that had been milked on the spot because a cow had been brought to the house from the garden of Gualfonda". For two days, anyone was allowed to visit the palazzo, and visitors of the time recall a stream of some 30,000 people: "and it was decided to open all the doors so everyone could do and satisfy themselves in their own manner".

However, as we know, such displays of luxury were no longer matched by solid finances. In 1810 the palace was

handed over to the state property office and transferred to the State four years later.

Retracing our steps and going to the glazed corridor and then the exit stairs, also the result of modifications made following the building's purchase by the Province of Florence, we once again descend to the courtyard of columns – the fulcrum, in the past and the present, of a palazzo which, despite and as a consequence of the complex articulations of almost five centuries of history, we can still call "magnificent".

 ## THE BIBLIOTECA RICCARDIANA AND THE BIBLIOTECA MORENIANA

Letters and studies are a magical secret, which binds together powerfully men of different tongues and customs, divided and rendered averse by very large stretches of land and sea [...]. (Anton Maria Salvini, *Discorsi accademici*, 1821).

The Biblioteca Riccardiana has a similar spatial configuration to that of the adjacent gallery. Though the arrangement and decoration are freer and bolder, their elegance and freshness is exalted to the full: the fresco on the vault – the *Allegory of Divine Wisdom,* painted by Luca Giordano in just five days between 1685 and 1686, according to the architect Nicodemus Tessin the Younger – is complementary to the adjacent vault of the gallery. Here, in fact, again taking advice from Alessandro Segni, "one sees Intellect which, released by the Sciences from the bonds of earthly ignorance, and attired with wings of celestial reason, rises into flight and contemplates truth, which, entirely naked and covered only by its divine light, is at the feet of Divinity itself".

Arranged along the walls there are still two series of elegant walnut bookcases. The stucco decoration was once again the work of the Ciceri brothers and Anton Francesco Andreozzi: around the fresco there are plant decorations and inscriptions supported by putti. While the nucleus of the library had already taken shape by the end of the sixteenth century, with the bibliophile Riccardo Riccardi, it was his nephew Francesco who arranged the volumes in a specially designed and appropriate environment, while at the same time adding considerably to the collection. This was further enlarged by the Capponi inheritance, comprising around 5,200 print works and 249 manuscripts, which arrived as a result of Francesco's marriage to Cassandra Capponi. In the library, today's reading room for the public, it is still possible to see the Riccardi-Capponi crest on one side and the marble bust of Vincenzo Capponi on the other. Their son Cosimo continued to build the collection, though the greatest contribution came from the subdeacon Gabriello (1705–1798), an enthusiastic bibliophile, and it was at his behest that a further room was built in 1786. Neo-classical in taste, it was dedicated to the Muses and Minerva, with oval

LEVANDO
TERRA AL CIEL
NOSTRO
INTELLETTO

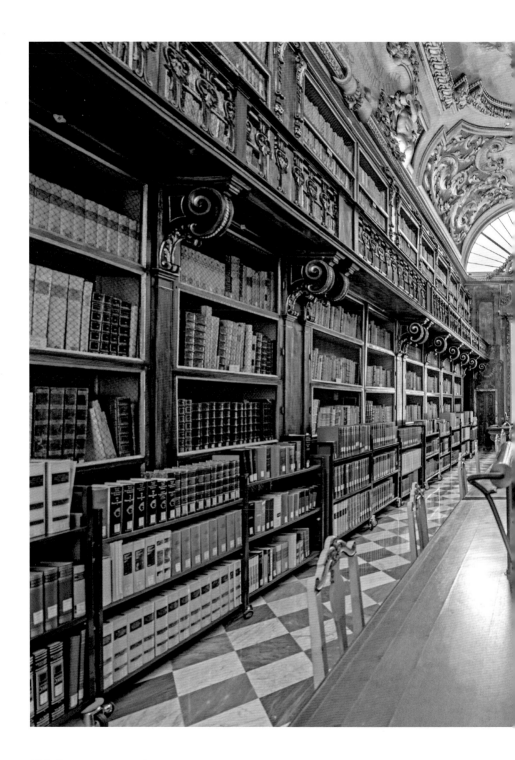

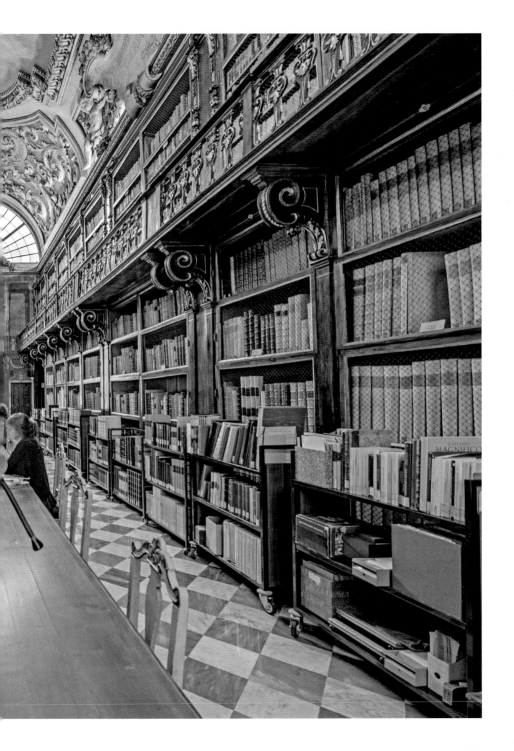

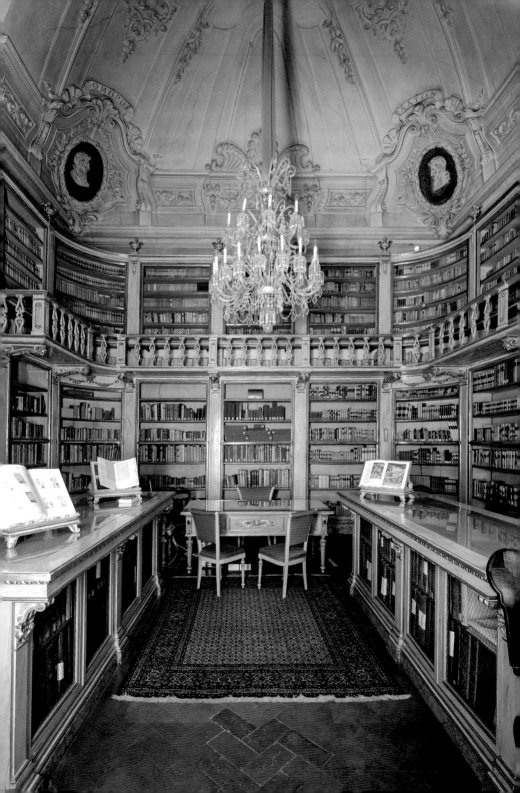

corners depicting Cicero, Homer, Virgil and Plato. He also granted access to scholars for the first time. Significant impetus came first from the librarian, erudite and antiquarian Giovanni Lami, in service at the palazzo from 1733 and the initiator of lively cultural exchanges, and then from Abbot Francesco Fontani, who fought for the survival of the library after it passed into the hands of the state property office, with the acquisition by the Comune in 1813 and its subsequent transfer to the State. Bequests and donations continued in the nineteenth century as well, resulting in a rich and varied corpus: besides many Latin manuscripts, the library holds Arab and oriental codices, a body of codices in Greek and precious incunabula (including the Bible that belonged to Savonarola) and theatrical texts.

The Biblioteca Moreniana, on the other hand, is in two adjacent rooms, the vaults of which were frescoed at the end of the seventeenth century by Giuseppe and Tommaso Nasini with *Hercules at the Crossroads* and *Jupiter Destroying the Giants*, mythological subjects with moralizing references; the framings are by Francesco Sacconi. The library is named after Canon Domenico Moreni (1763–1835), its initial champion. He was a passionate collector of manuscripts and printed books, with a particular fondness for Tuscan works, and the author of the first *Bibliografia storica ragiona-*

ta della Toscana. Having grown with the addition of the collection of Pietro Bigazzi, it was acquired by the Province of Florence in 1868 and transferred to the palace ten years later.

To the north of the courtyard of mules, with an independent entrance from via Cavour and via Ginori, is the galleria of carriages. This long vaulted gallery, around seventy metres in total, was built at the wishes of Gabriello Riccardi to a design by the architect Pier Maria Baldi. The name derives from the many carriages that were taken to be kept there, including, in 1671, "a French-style six-seater carriage, with black cowhide exterior and red sumac interior [...] a six-seater country carriage with red cowhide cushions and black cowhide and red kidskin bands with black nails and a mirror, [...] an open gig covered with cowhide and red cloth curtains with yellow decoration, with steering and four wheels" (Florence, Archivio di Stato, Riccardi, 266, cc. 24v-28r). Reopened to the public in 2009, it now hosts temporary exhibitions and events. ▣

Printed on the presses of Tipolitografia Pagani,
Passirano, Italy, in the month of July 2021.

ex Officina Libraria Jellinek et Gallerani